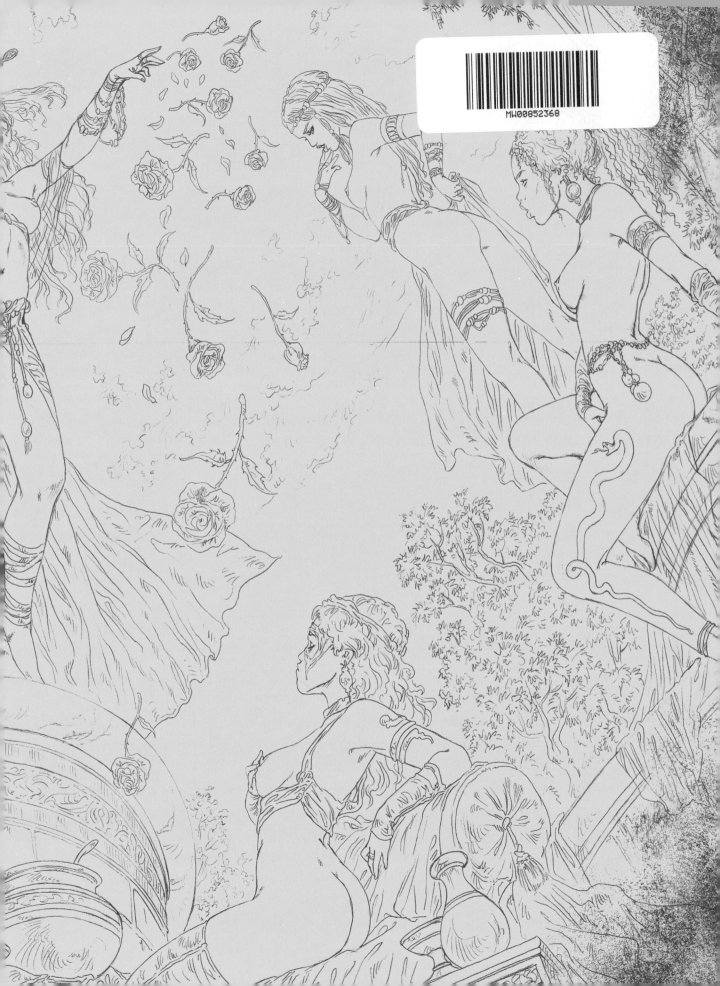

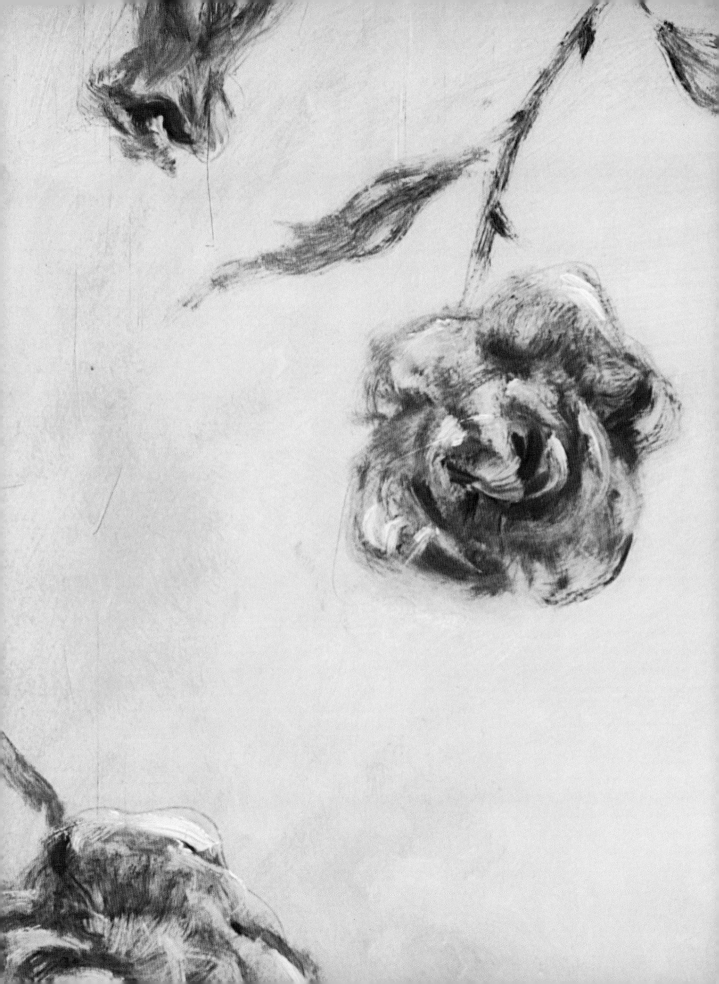

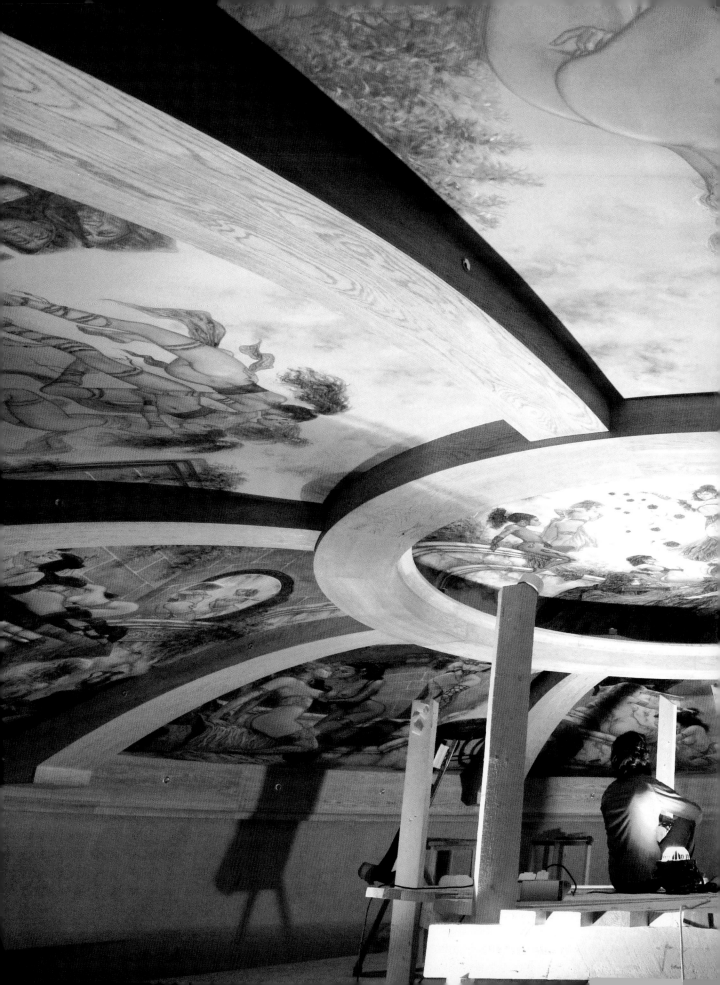

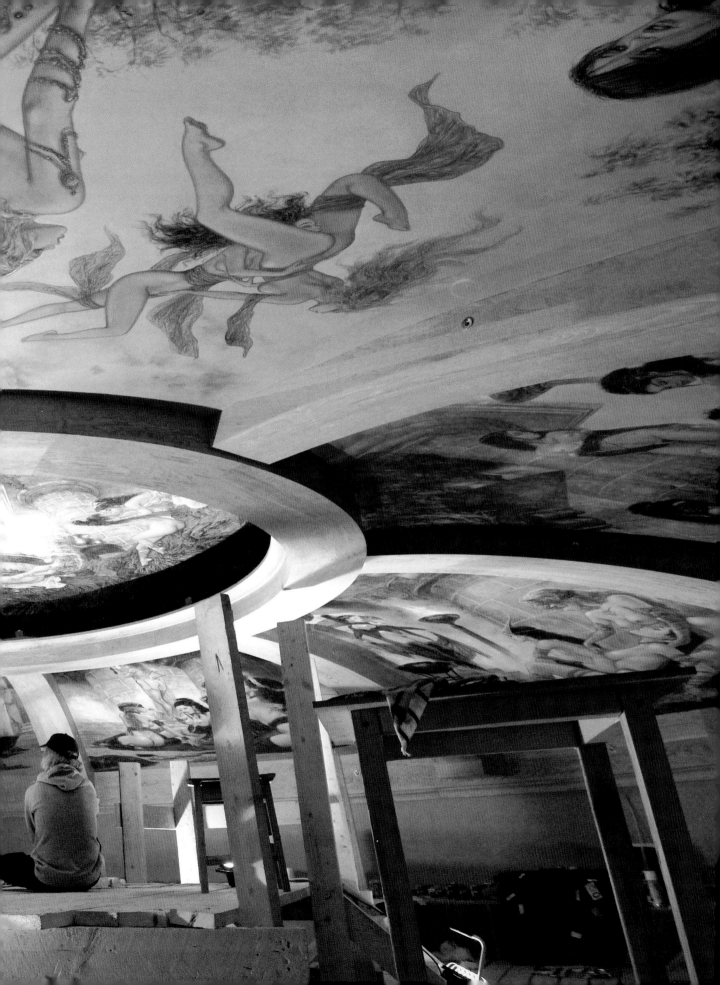

DOME, by Luis Royo & Romulo Royo

Primera Edición / First Edition: June 2007.

Fotografías / Pictures:
Luis Royo & Romulo Royo

Diseño / Design: Pau Serra

© Luis Royo / Represented by
Norma Editorial, S.A.

Norma ISBN: 978-84-9847-083-3
Depósito Legal: B-13465-2007

Heavy Metal ISBN: 978-19324-13809.

Printed in the EU.

www.LuisRoyo.com

DOME

LUIS ROYO ROMULO

INTRODUCCIÓN

INTRODUCTION – INTRODUCTION – EINLEITUNG – INTRODUZIONE

Luis Royo y yo ocupamos el asiento trasero de un Bentley que circula a más de doscientos por hora, clavados a la tapicería de cuero, sudando. Hay caravana, y el conductor ha decidido poner en marcha una sirena y pasarse al carril contrario, ocupado por coches que vienen de frente. Cuando el impacto parece inevitable, cerramos los ojos... pero los otros conductores ceden y se apartan.

Estamos en Moscú, y en el asiento de delante va nuestro cliente, que no se altera por el peligro. Me llamó un par de meses antes para preguntarme si Luis Royo estaría dispuesto a pintar un fresco sobre una cúpula de 80 metros cuadrados en el nuevo castillo que estaba construyendo cerca de Moscú. Mi reacción fue de sorpresa y escepticismo, pero a los pocos días se presentaba en Barcelona para, tras siete horas de reunión en presencia de Luis, llegar a un acuerdo. Nos comprometimos a realizar un trabajo realmente titánico.

Coincidió que por aquellos días estaba leyendo el maravilloso libro de Robert Hughes sobre Goya, y las vicisitudes del artista aragonés trabajando para la corte y el clero en el siglo XVIII me recordaban a las que estaban pasando en Moscú Luis y su hijo, el pintor Rómulo Royo, que le ha ayudado en toda esta aventura. El clima gris y las expresiones serias de la mayoría de personas que nos rodeaban nos hacían sentir extraños. Parecía que habíamos retrocedido en el tiempo unos cuantos lustros.

Sin duda, Luis se ha enfrentado a muchos retos a lo largo de su extensa trayectoria profesional, pero pintar una cúpula le producía una sensación nueva, apasionante y única. Supongo que tenía la impresión de que el fresco iba a perdurar más que cualquier otro trabajo realizado antes. Luis es un autor que siente atracción por los desafíos, pero éste era muy especial, y puedo asegurar que se ha entregado a él por completo durante los seis meses de 2006 que duró su gestación.

Nuestro cliente no pidió que pintara cuarenta y cinco chicas de dos metros de altura cada una. Podía haber llenado el espacio con la mitad, pero Luis ha creado nueve escenas en las que las mujeres se acarician, se observan, se miman y embellecen. Una obra y una experiencia que ahora llega hasta vuestras manos, para que podáis compartir junto a sus protagonistas una aventura inolvidable.

Luis Royo and I were in the back seat of a Bentley driving at more than 120 miles per hour, gripping the lush upholstery for dear life. We had been sitting in a traffic jam on the outskirts of Moscow when suddenly the driver got spooked and in one seamless, perhaps practiced move, jumped the median, sounded a siren, and surged towards the oncoming traffic. We closed our eyes and braced ourselves for what surely would be serious impact. But like a salmon swimming upstream, the Bentley forced its way through the quagmire leaving the traffic in its rear view mirror.

In the front seat, and apparently immune from the near death experience we had just shared, was our client. A few months earlier he had called to ask if Luis Royo would be willing to paint a fresco in an 80-meter dome in the new castle he was building near Moscow. I was skeptical. I trade in the delicate art of encouraging such flights of fancy always knowing that I'm more than likely playing Daedalus to another Icarus. But, to my surprise, just a day later he was in my office in Barcelona. After a full day of negotiating Luis accepted the commission, the biggest of his career.

Luis has previously undertaken many challenges throughout his professional life but painting a dome this size was a daunting, yet thrilling prospect. The sheer scale was intoxicating. He is grateful for the help of his son, the painter Rómulo Royo, as they joined forces to create this spectacular vision. For six months Royo was devoted exclusively to this project: a fresco he hoped would have a permanency beyond the painted canvases he usually paints.

During this period I was reading GOYA by Robert Hughes and the parallels of our present commission to the vicissitudes of the Aragonese artist working for the court and the clergy in the 18th century was not lost on me. There was a startling contrast of the exotic world Royo was creating under the dome and the gray drab climate reflected in the sturdy expressions of the Muscovites we sped past. It was as if we had gone back in time.

Our client had asked him to paint 45 life-sized women. The space could have been full with half that amount but Luis created nine scenes in which the women caress, frolic, and enjoy each other, uninhibited in their quest for sensual pleasures.

I hope that in presenting this intimate experience and sharing some of this adventure you will gain some insight into the exquisite talent of Luis Royo.

Luis Royo et moi-même occupons le siège arrière d'un Bentley qui circule à plus de deux cents à l'heure, cloués à la tapisserie en cuir, nous transpirons. Il y a des embouteillages, et le conducteur a décidé de déclencher une sirène et de passer sur la voie contraire, occupée par des voitures qui viennent en face. Quand le choc paraît inévitable, nous fermons les yeux...mais les autres conducteurs cèdent et s'écartent du chemin.

Nous sommes à Moscou, notre client est assis à l'avant, et le danger ne paraît pas l'inquiéter. Il m'a appelé il y a deux mois pour me demander si Luis Royo accepterait de peindre une fresque sur une coupole de 80 mètres carrés dans le nouveau château qu'il est entrain de construire près de Moscou. Je réagis d'abord avec surprise et scepticisme, mais très vite, il se présente à Barcelone et après une réunion de sept heures en présence de Luis, tous deux parviennent à un accord. Nous nous engageons dès lors à réaliser un travail réellement grandiose.

Par un étonnant hasard, j'étais entrain de lire le merveilleux livre de Robert Hughes sur Goya, et les vicissitudes de l'artiste aragonais qui travaillait pour la cour et l'église au XVIIIème siècle et qui me rappelaient celles que vivaient Luis et son fils, le peintre Romulo Royo, qui l'aida dans toute cette aventure. Le climat gris et les expressions sérieuses de la plupart des personnes qui nous entouraient nous faisaient nous sentir différents. On avait cette impression qu'on avait reculé dans le temps de quelques siècles.

Luis s'était déjà imposé beaucoup de défis tout au long de sa longue trajectoire professionnelle, mais peindre une coupole réveillait chez lui une sensation nouvelle, passionnante et unique. Je suppose qu'il avait l'impression que cette fresque allait durer plus que tout autre travail réalisé antérieurement. Luis est un artiste qui ressent une attirance pour les défis, bien que celuici fût réellement particulier, et je peux vous assurer qu'il se livra à lui totalement pendant les six mois de l'année 2006 que dura cette réalisation.

Notre client ne lui demanda pas de peindre quarante cinq jeunes filles de deux mètres de haut chacune, la moitié aurait suffi à remplir l'espace, mais Luis créa neuf scènes dans lesquelles les femmes se caressent, s'observent, se soignent et se font belles.

Une œuvre et une expérience qui arrive dans vos mains, pour que vous puissiez partager avec ses personnages à lui, une aventure inoubliable.

Luis Royo und ich sitzen auf der Rückbank eines Bentleys. Bei mehr als 200 Kilometer pro Stunde pressen wir uns schwitzend in die Lederpolster. Wir kommen in einen Stau und der Fahrer beschließt, eine Sirene einzuschalten und auf der Gegenspur weiterzufahren, trotz der entgegenkommenden Fahrzeuge. Als ein Zusammenstoß unvermeidlich scheint, schließen wir die Augen… Aber die anderen Fahrer geben nach und weichen aus.

Wir befinden uns in Moskau und auf dem Beifahrersitz fährt unser Kunde, der sich durch die Gefahr nicht erschüttern lässt. Vor einigen Monaten rief er mich an um mich zu fragen, ob Luis Royo bereit wäre, ein Fresko auf eine 80 Quadratmeter große Kuppel zu malen in dem neuen Schloss, das er gerade in der nähe von Moskau errichten ließ. Ich war überrascht und skeptisch, aber einige Tage später erschien er in Barcelona und nach einer siebenstündigen Verhandlung in Anwesenheit von Luis kamen wir zu einer Vereinbarung. Wir verpflichteten uns dazu, ein wahrlich titanisches Werk fertig zu stellen.

Zufälligerweise las ich zu jener Zeit gerade das wundervolle Buch von Robert Hughes über Goya, und die Wechselfälle des aragonischen Künstlers, der während des 18. Jahrhunderts für Hof und Klerus arbeitete, erinnerten mich an diejenigen, die Luis und sein Sohn, der Maler Rómulo Royo, der ihn bei diesem Abenteuer beistand, in Moskau erlitten. Durch das graue Klima und die ernsten Gesichter der Mehrzahl der Personen, die uns umgaben, fühlten wir uns fremd. Es erschien uns, als wäre die Zeit ein paar Jahrzehnte zurückgedreht.

Ohne Zweifel hat sich Luis während seiner vielseitigen beruflichen Laufbahn mit vielen Herausforderungen konfrontiert gesehen, aber die Aussicht, eine Kuppel zu bemalen, erzeugte in ihm ein neues, überwältigendes und einzigartiges Gefühl. Ich nehme an, er hatte den Eindruck, dass ein Fresko länger Bestand haben würde, als jedes der anderen Werke, die er zuvor erschaffen hatte. Luis ist ein Künstler, den Herausforderungen anziehen, aber diese war etwas besonderes, und ich kann versichern, dass er sich ihr während der sechs Monate des Jahres 2006, die er für die Fertigstellung benötigte, voll und ganz gewidmet hat.

Unser Kunde bat um die Darstellung von fünfundvierzig Mädchen in einer Größe von zwei Metern. Die Hälfte hätte gereicht, um die Fläche auszufüllen, aber Luis erschuf neun Szenen, in denen sich die Frauen streicheln, sich beobachten, sich verwöhnen und schmücken. Eine Erfahrung und ein Werk, das heute in Eure Hände fällt, damit ihr mit seinen Protagonisten ein unvergessliches Abenteuer teilen könnt.

Io e Luis Royo occupiamo il sedile posteriore di una Bentley che circola a più di duecento chilometri all'ora, inchiodati alla tappezzeria di cuoio, sudando. C'è traffico, e il conducente ha deciso di accendere una sirena e di passare nella corsia opposta, occupata da macchine che vengono contro di noi. Quando l'impatto sembra ormai inevitabile, chiudiamo gli occhi...ma gli altri conducenti cedono e si fanno da parte.

Siamo a Mosca, e nel sedile anteriore c'è il nostro cliente, che non si altera di fronte al pericolo. Mi ha chiamato qualche mese fa per chiedermi se Luis Royo sarebbe stato disposto a dipingere un affresco su una cupola di 80 metri quadrati nel nuovo castello che stava costruendo vicino Mosca. Ebbi una reazione di sorpresa e di scetticismo, ma qualche giorno dopo si presentò a Barcellona e, dopo sette ore di riunione in presenza di Luis, arrivammo a un accordo. Ci impegnammo a realizzare un'impresa davvero titanica.

In quei giorni stavo giusto leggendo quel meraviglioso libro di Robert Hughes su Goya, e le vicissitudini dell'artista aragonese del XVIII secolo che lavorava per la corte e per il clero, mi ricordavano quelle che stavano vivendo a Mosca Luis e suo figlio, il pittore Rómulo Royo, che l'ha aiutato in tutta questa avventura. Il clima grigio e le espressioni serie della maggior parte delle persone che ci circondavano, ci facevano sentire come degli estranei. Era come se fossimo andati indietro nel tempo.

Senza dubbio, Luis ha affrontato molte sfide nella sua lunga traiettoria professionale, ma dipingere una cupola gli produceva una sensazione nuova, appassionante e unica. Probabilmente aveva l'impressione che l'affresco perdurasse nel tempo, più di qualsiasi altro lavoro realizzato fino a quel momento. Luis è un autore che si sente attratto dalle sfide, ma questa era speciale, e posso assicurare che si è dato ad essa completamente per quei sei mesi del 2006 durante i quali portò a termine l'impresa.

Il nostro cliente non ci chiese di dipingere quarantacinque ragazze, ognuna alta due metri. Avrebbe potuto riempire lo spazio con la metà di esse, ma Luis ha creato nove scene in cui le donne si accarezzano, si osservano, si coccolano e si fanno belle. Un'opera e un'esperienza che arriva adesso nelle vostre mani, perché possiate vivere con le sue protagoniste un'avventura indimenticabile.

Rafa Martínez
Publisher

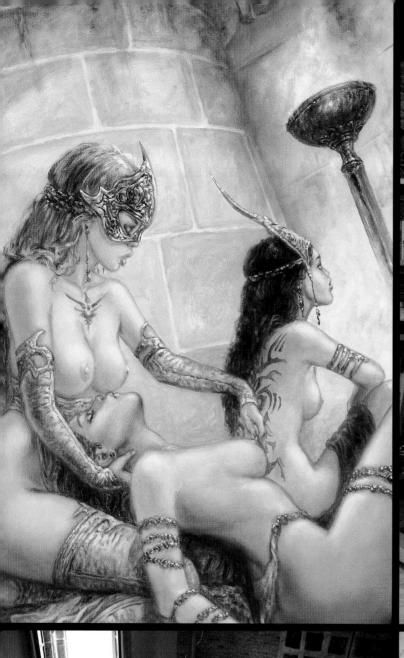

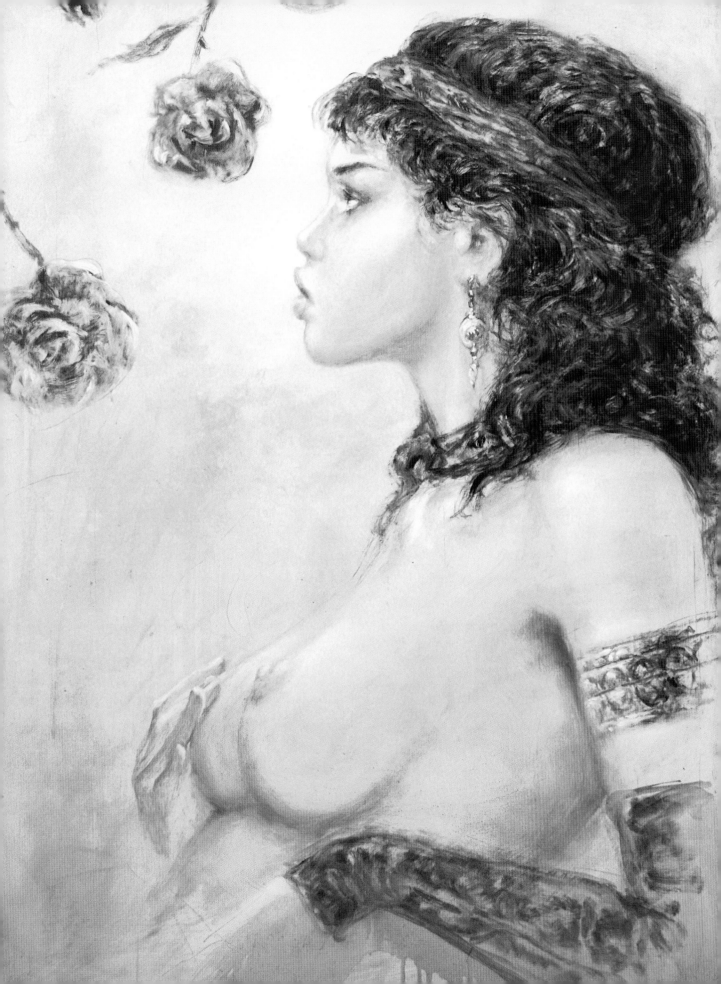

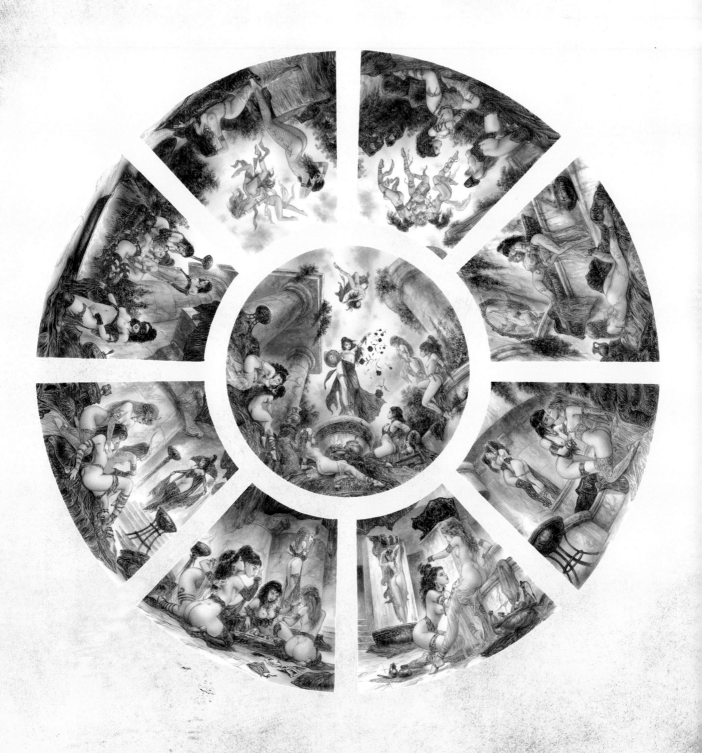

Boceto — Sketch — Esquisse — Skizze — Bozzetti

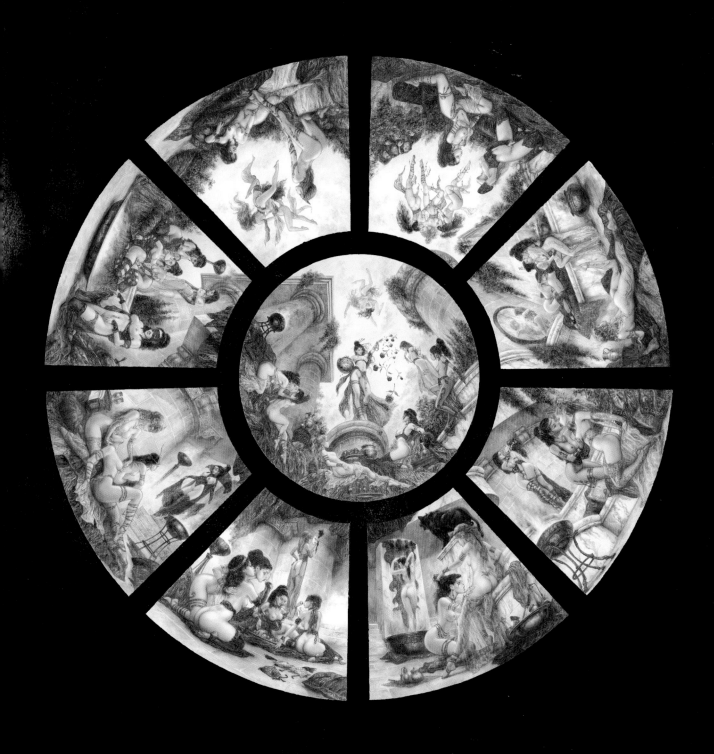

Imagen final — Final image — Image finale — Fertiges bild — Imagine finale

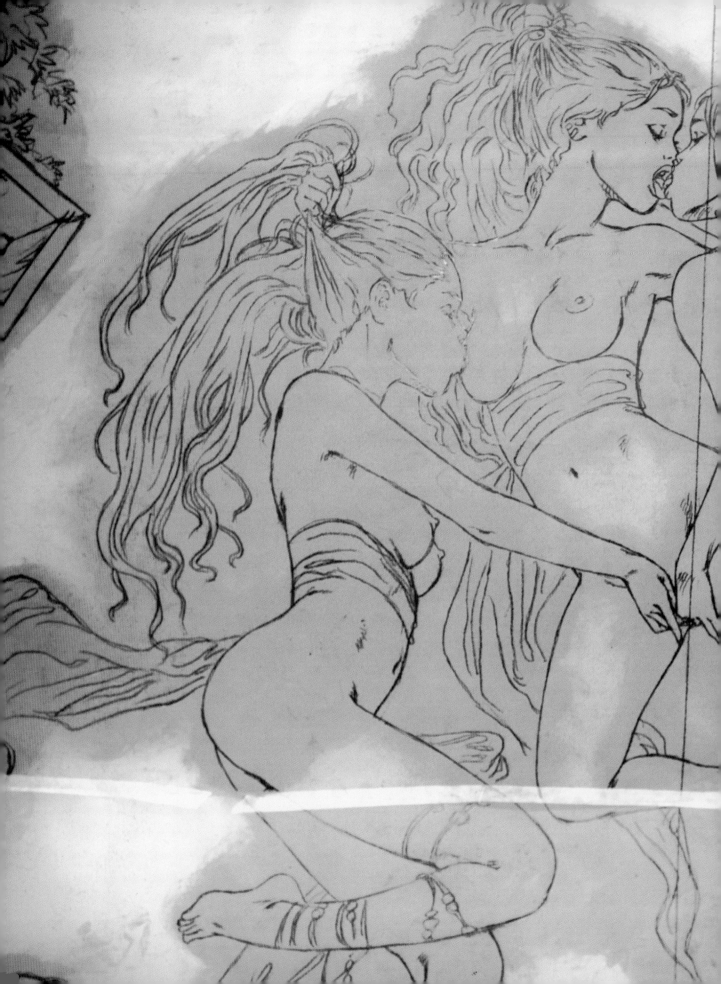

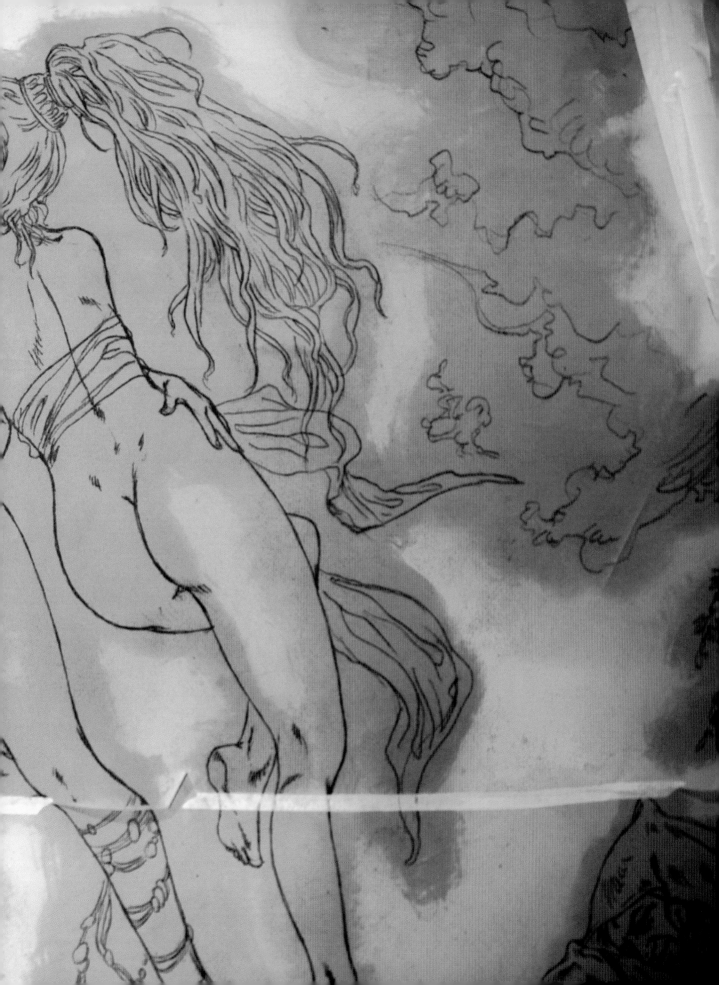

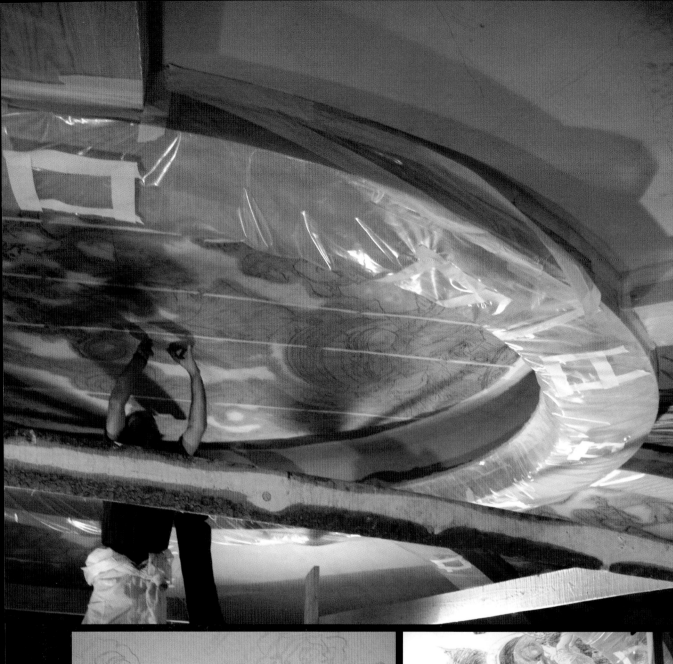

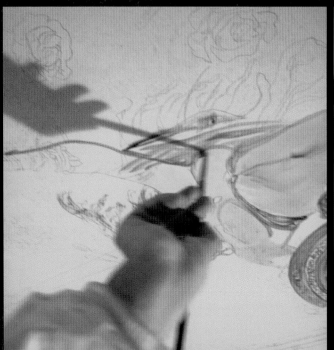

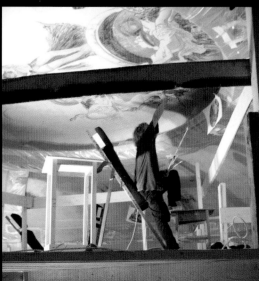

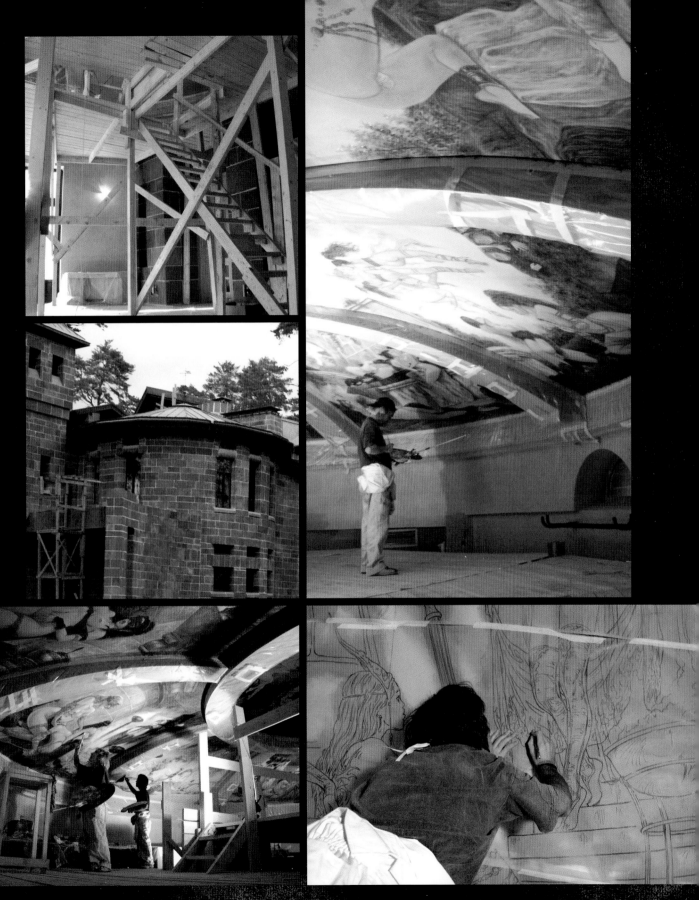

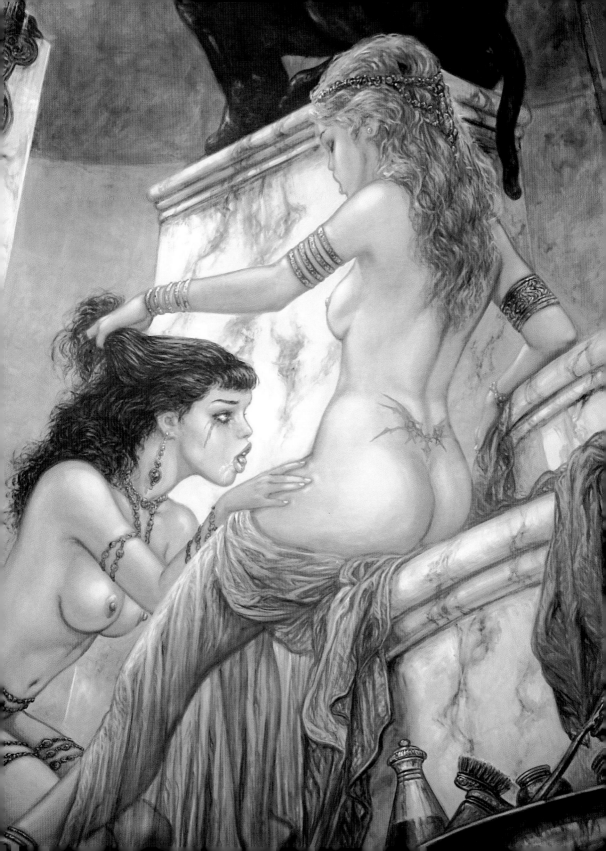

¿Cómo resistirse a un reto tan atractivo? A sentirse envuelto por un universo morboso y provocador, y a vivir por un tiempo literalmente dentro de él. ¿Cómo rechazar el encargo de pintar una cúpula en Moscú?

How can you resist such an attractive challenge? To feel absorbed in a morbid and provocative universe, and to live literally within it for some time. How to turn down the offer of painting a dome in Moscow?

Comment résister à une proposition si alléchante? Comment résister à l'idée de te sentir enveloppé par un univers morbide et provocateur, et y vivre pendant un certain temps? Comment refuser la commande de peindre une coupole à Moscou?

Wie könnte ich einer so attraktiven Herausforderung widerstehen? Ein morbides und aufreizendes Universum, in dem ich während einer gewissen Zeit buchstäblich wohnen würde. Wie könnte ich den Auftrag ablehnen, eine Kuppel in Moskau zu bemalen?

Come si può resistere a una sfida così seducente? A sentirsi avvolto da un universo morboso e provocante ed a vivere per qualche tempo letteralmente dentro di esso? Come si può rifiutare l'incarico di dipingere una cupola a Mosca?

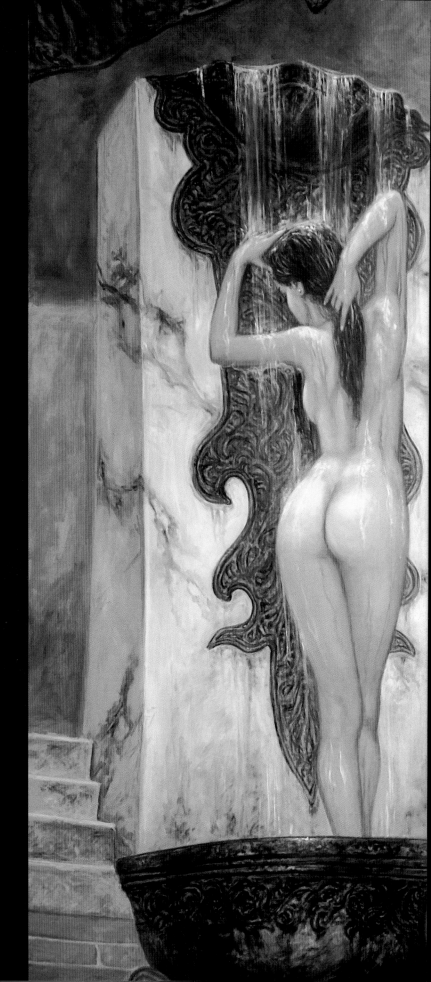

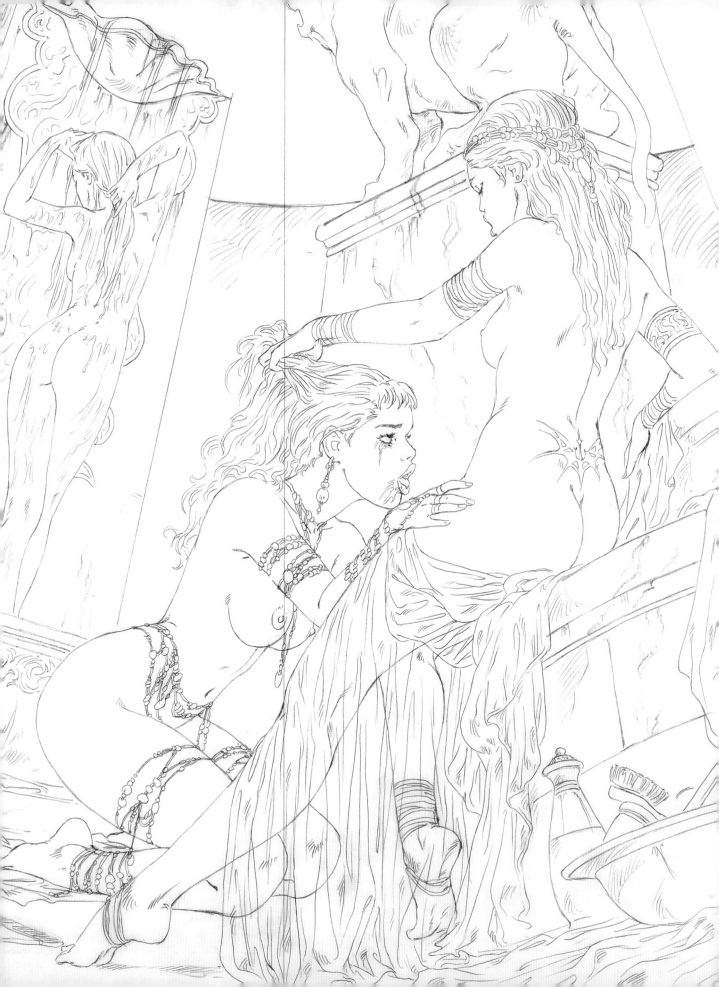

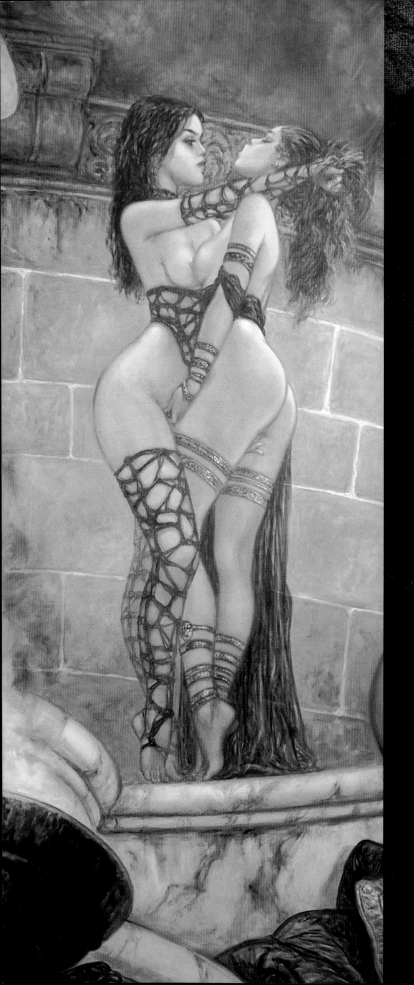

La gestación del proyecto y los primeros bocetos en Barcelona fueron acompañados por cientos de dudas. Realizar una cúpula de dimensiones considerables en Rusia suponía pasar bastante tiempo en un país frío, bajo un intenso y continuo desgaste físico. Era consciente de que todo ese esfuerzo pasaría factura.

From the initial sketches, the project was burdened by hundreds of thoughts and decisions. To paint a large dome in Russia meant committing to a long time in a cold country under less than ideal circumstances. I was aware this effort could extract an emotional and physical toll on me.

La gestation du projet et les premières ébauches à Barcelone soulevèrent de nombreux doutes. Réaliser une coupole aux dimensions considérables en Russie impliquait devoir passer un certain temps dans un pays froid, sous une tension physique continue. Etaistu conscient que tout cet effort aurait ses conséquences?

Die Ausarbeitung des Projekts und die ersten Skizzen in Barcelona brachten mir Hunderte von Zweifeln ein. Die Gestaltung einer Kuppel von beachtlicher Größe in Russland bedeutete, dass ich viel Zeit in einem kalten Land verbringen müsste unter einer großen und fortwährenden körperlichen Anstrengung. Ich wusste, dass dieser Kraftakt seinen Zoll fordern würde.

La preparazione del progetto ed i primi bozzetti fatti a Barcellona sono stati accompagnati da centinaia di dubbi. Realizzare una cupola di dimensioni considerevoli in Russia implicava trascorrere un bel pò di tempo in un paese freddo, andando incontro a un intenso e continuo logorio fisico. Sapevo che tutto questo sforzo alla fine mi avrebbe presentato il conto.

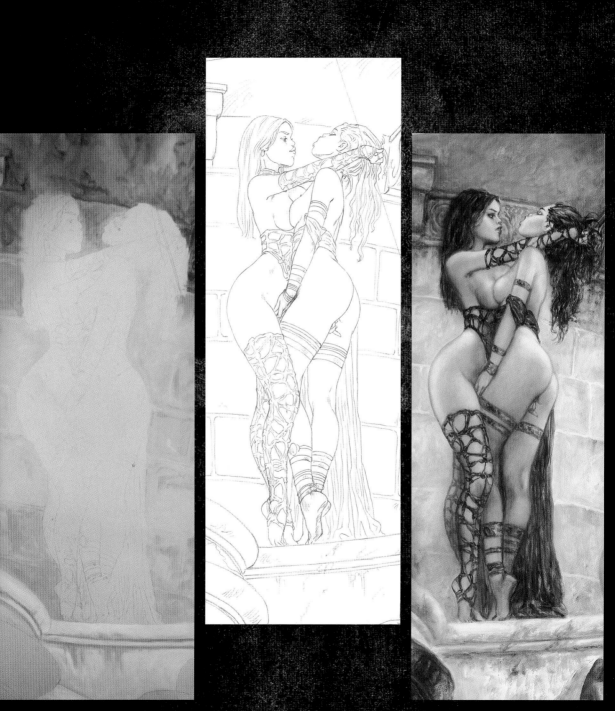

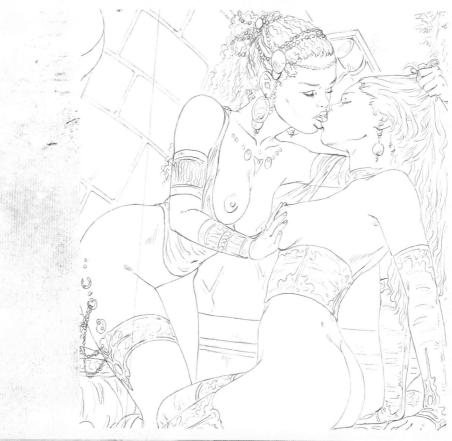

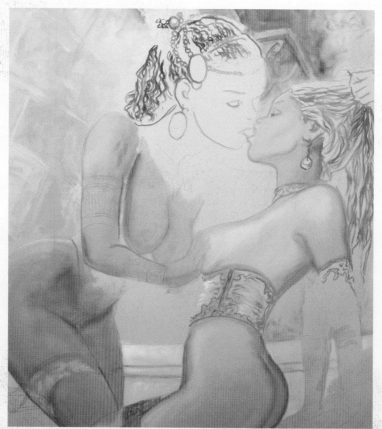

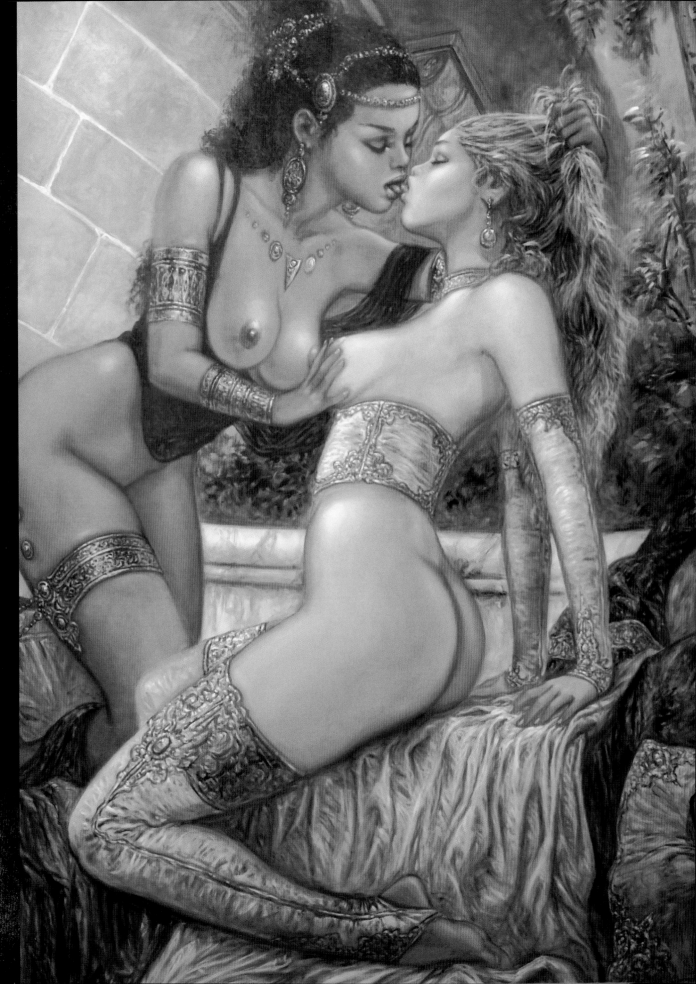

Todo se preparó en Barcelona: lápices, primeros bocetos a color, lienzos a escala con todas las tonalidades y la composición definiti-va, e incluso la línea completa de dibujos a tamaño natural. También se hicieron pruebas del empleo de barnices, tapaporos y óleos sobre la escayola; la intención era realizar un fresco al estilo clásico, haciendo penetrar el pigmento en el yeso, pero con las ventajas de los mate-riales del siglo XXI.

Everything was prepared in Barcelona: concepts, first pencil sketches, first colour sketches, scaled canvasses with tonal values and the final compositions along with a complete breakdown of the sequence of paintings on a real life scale. Tests were made with various oil paints on plaster as well as on compatible varnishes. The goal was to do a fresco in the classical style, which requires the colour paint to soak into the plaster. The advantage was working with 21st century materials.

Tout eut lieu à Barcelone, choix des crayons, premières ébauches en couleur, toiles à échelle avec toutes les tonalités et la composition définitive, et même la ligne complète de dessins grandeur nature. Des essais d'emploi de vernis furent également faits, de couvre-pores et d'huiles sur le plâtre, l'intention était de réaliser une fresque de style classique, faisant pénétrer le pigment dans le plâtre, mais avec les avantages des matériaux du XXIème siècle.

Alles wurde in Barcelona vorbereitet: die Zeichenstifte, die ersten farbigen Skizzen, maßstabsgerechte Gemälde in allen Schattierungen und die endgültige Komposition, sogar die vollständige Zeichnung in Lebensgröße. Auch wurden die Lacke, Grundierungen und Ölfarben auf Gips aus-probiert. Es sollte ein Fresko im klassischen Stil werden, die Pigmente sollten in den Gips eindringen, aber mit allen Vorteilen der Materialien des 21. Jahrhunderts.

Preparai tutto a Barcellona: matite, i primi bozzetti a colore, tele in scala con tutte le tonalità e con la composizione definitiva, e perfino la linea completa dei disegni a grandezza naturale. Ho fatto anche la prova d'uso delle vernici, degli smalti e degli oli sul gesso. L'intenzione era quella di realizzare un affresco in stile classico, facendo penetrare il pigmento nel gesso, ma con i vantaggi dei materiali del XXI secolo.

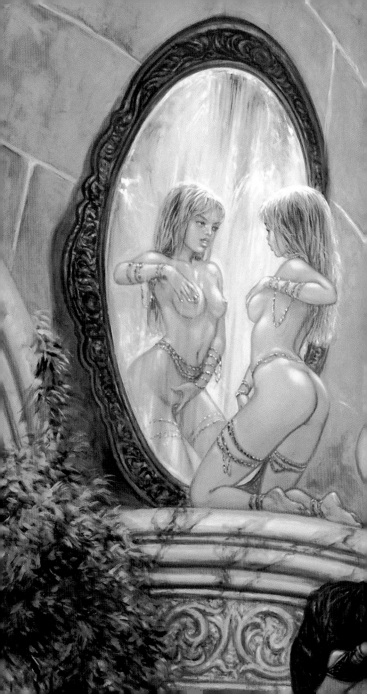

Por otro lado, para ir a Moscú se diseñaron banquetas de inclinación regulable que sujetaran y mantuvieran recta toda la columna vertebral, y nos aprovisionamos de los mismos óleos, barnices y pinceles con que habíamos realizado las pruebas.

Benches with variable inclination were also designed, so that the spine would be in a correct posture at all angles. These were shipped to Moscow along with the crates of oil paints, varnishes and brushes.

D'un autre côté, pour aller à Moscou, on eut l'idée de créer des banquettes d'inclination réglable pouvant maintenir droite la colonne vertébrale, et nous avons choisi les mêmes huiles, vernis et pinceaux que ceux utilisés pour les essais.

Auch wurden verstellbare Sitzvorrichtungen entworfen, welche die gesamte Wirbelsäule gerade hielten und für die Reise nach Moskau deckten wir uns ein mit den Ölfarben, Lacken und Pinseln, mit denen wir die Proben ausgeführt hatten.

Tra l'altro, per questa avventura moscovita sono stati disegnati degli sgabelli con l'inclinazione regolabile che sostengono e mantengono retta la colonna vertebrale. E, al momento di partire, ci siamo procurati gli stessi oli, vernici e pennelli che avevamo usato per le prove.

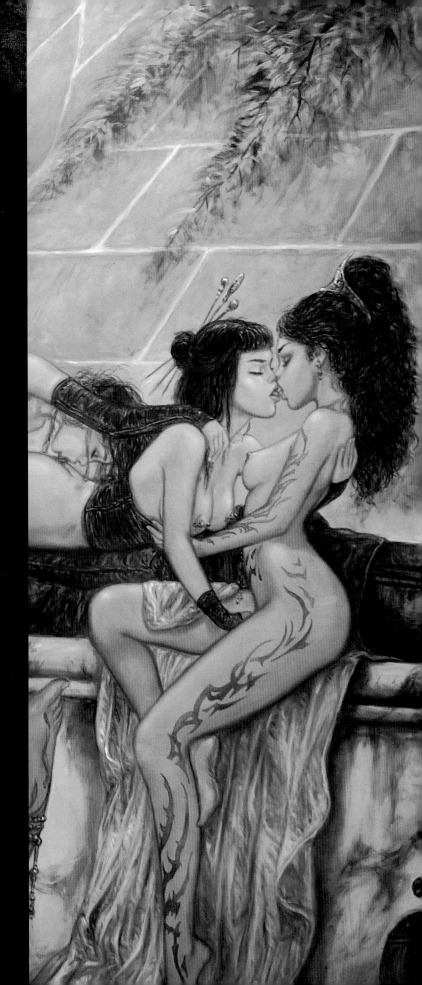

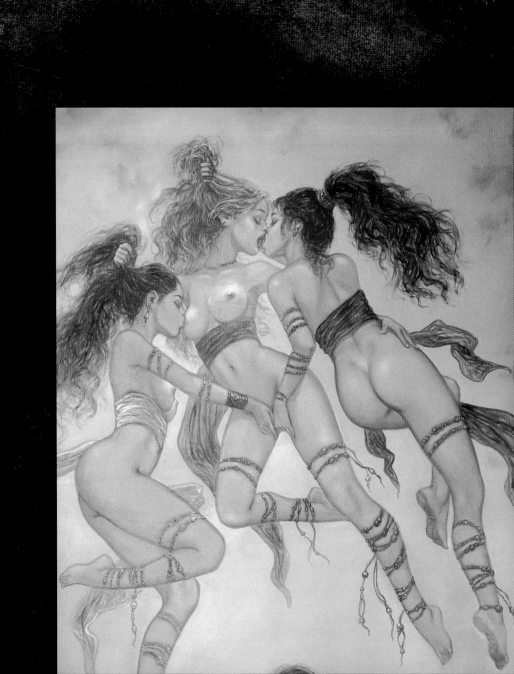

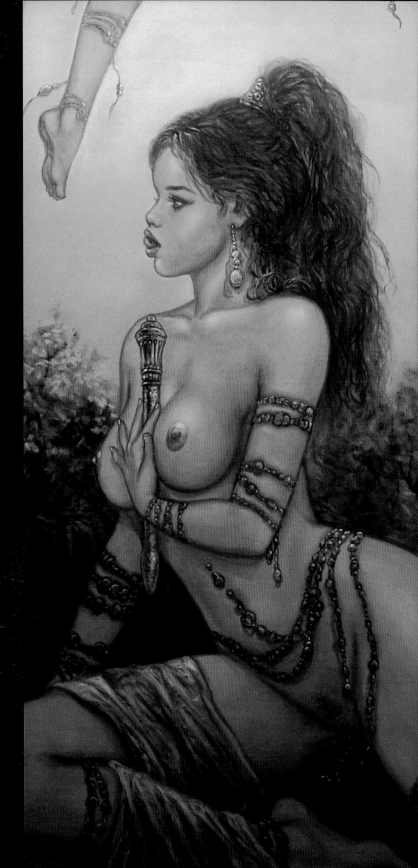

Una vez en el lugar, comprobamos la dureza del trabajo. Junto con Rómulo desgastamos más de cien pinceles arañando el yeso, vivimos encima de los andamios un día tras otro, subiendo antes de salir el sol y descendiendo cuando ya se había ocultado. Impregnando nuestro espíritu del peculiar aroma del óleo y el cielo frío y plateado de Rusia.

When I was finally at the location, I was able to assess the hardships ahead. Along with my son Rómulo we spent more than a 100 brushes scratching on the plaster, living on the scaffolding for days on end, climbing up on them before sunrise and descending after the sun had set. Our spirits were soaked with the peculiar aroma of the paints and of the cold and silvery skies of Russia.

Une fois sur place, nous avons pu vérifier la dureté du travail. Avec Romulo, nous avons utilisé plus d'une centaine de pinceaux et nous avons gratté le plâtre, nous passions nos jours sur les échafaudages, dès l'aube, jusqu'au coucher du soleil. Nous imprégnions notre esprit de l'odeur toute particulière des huiles et du ciel froid et argenté de Russie.

An Ort und Stelle mussten wir feststellen, dass die Arbeit sehr hart war. Zusammen mit Rómulo verschlissen wir auf dem Gips mehr als einhundert Pinsel. Wir lebten auf den Gerüsten, Tag für Tag. Wir bestiegen sie, bevor die Sonne aufging, und wir kamen erst herunter, als sie wieder untergegangen war. Unser Geist wurde von dem besonderen Aroma der Ölfarben und dem kalten und silbernen Himmel Russlands erfüllt.

Una volta sul posto, ci siamo potuti rendere conto della difficoltà del lavoro. Insieme a Rómulo abbiamo consumato più di cento pennelli nel tentativo di rigare il gesso. Abbiamo trascorso tanti giorni sulle impalcature: ci arrampicavamo su di esse prima del sorgere del sole e ne scendevamo quando già si era nascosto. Il nostro spirito si è impregnato del peculiare aroma dell'olio e del cielo freddo e argentato della Russia.

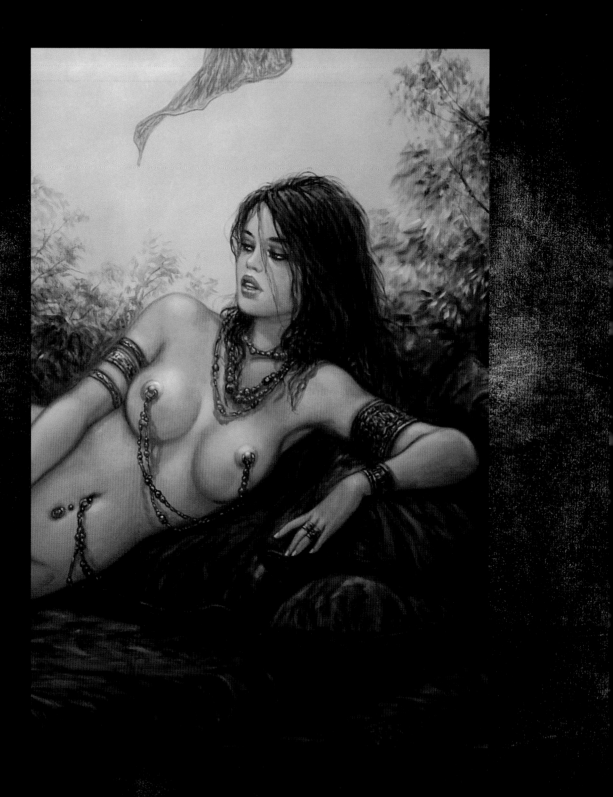

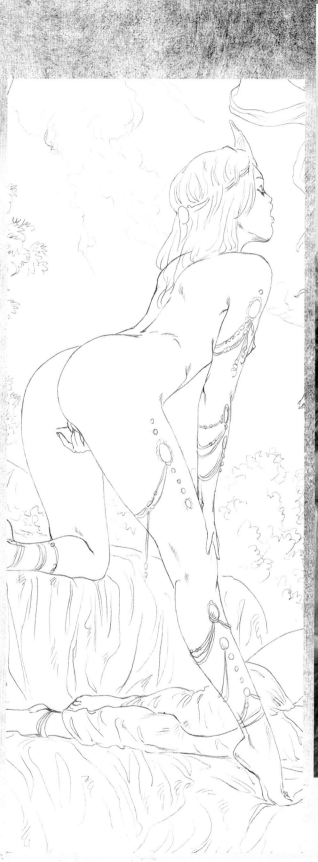
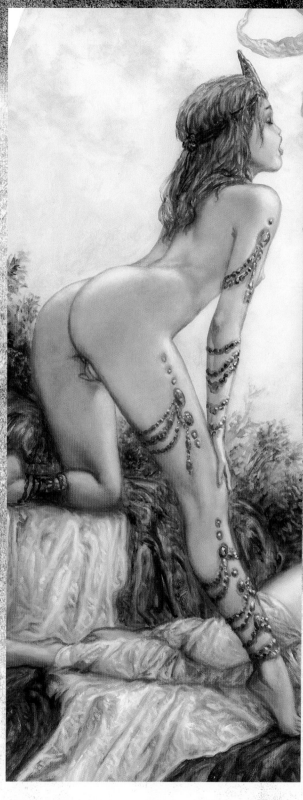

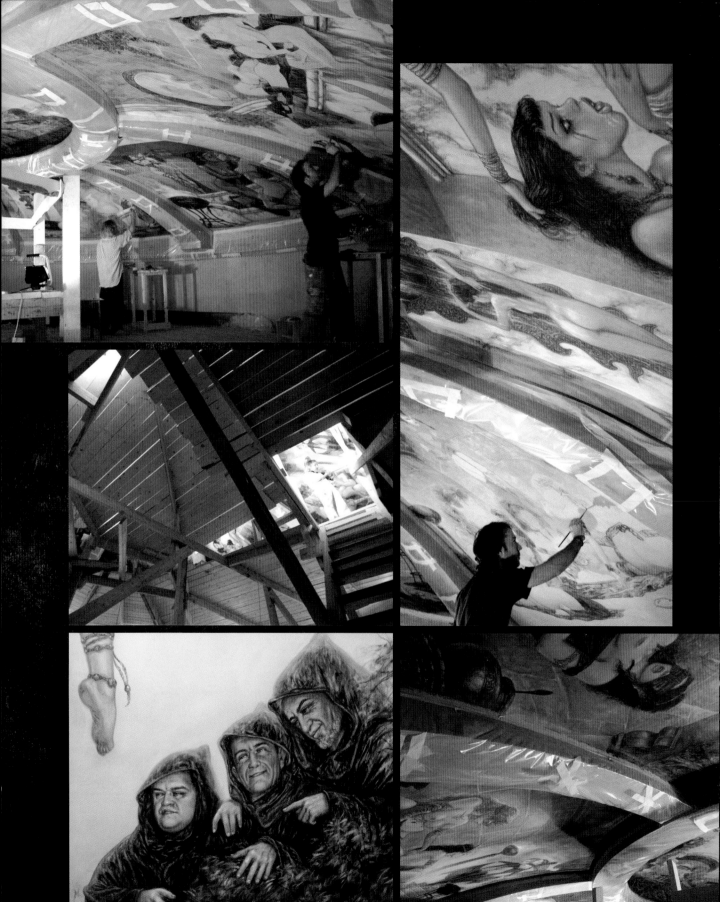

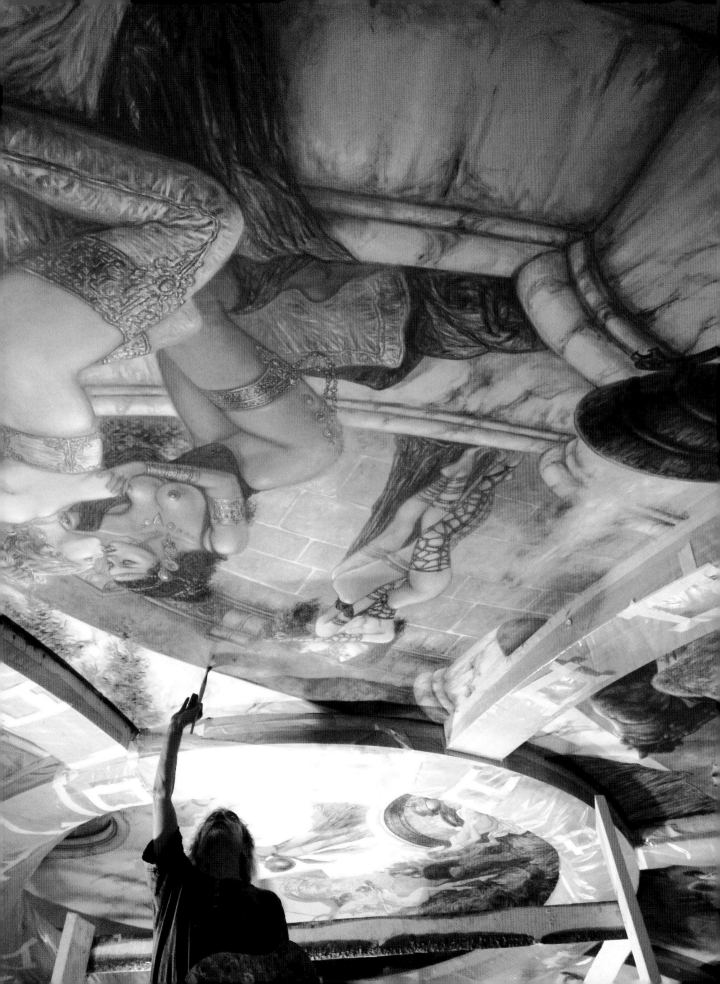

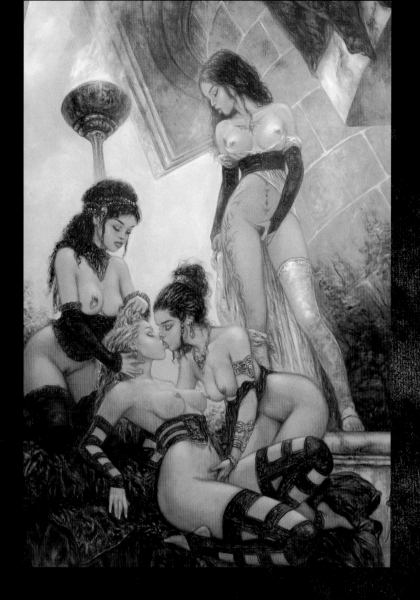

Durante esos meses vivimos y respiramos el mismo Renacimiento. No sólo el fresco, sino todo el entorno nos lo reflejaba.

During those months we lived and breathed in our own Renaissance. It wasn't just the fresco; it was the entire environment surrounding us.

Während dieser Monate lebten wir und atmeten wir die Renaissance. Nicht nur das Fresko, die gesamte Umgebung spiegelte sie uns wider.

Au cours de ces mois, nous avons vécu et respiré l'atmosphère même de la Renaissance. Et ce n'était pas uniquement la fresque qui nous y invitait mais tout l'univers dans lequel nous nous trouvions.

Durante questi mesi abbiamo vissuto e respirato il Rinascimento. Non era solo l'affresco, tutto l'ambiente attorno a noi ce ne rimandava i riflessi.

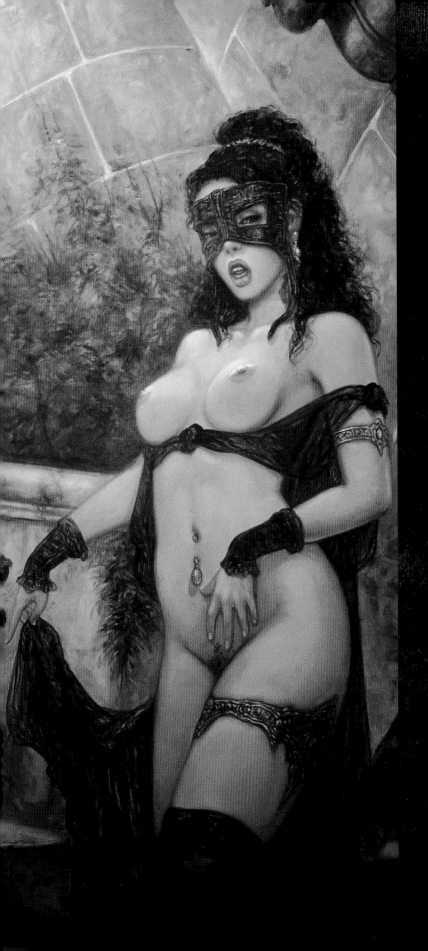

La cúpula está pintada con una arquitectura de perspectiva engañosa e imposible que unifica sus ocho segmentos con el dibujo central. Cada sección plasma una escena que representa una temática clásica del erotismo: la exhibición, el juego, la contemplación, el beso, etc., y se unen en un círculo donde la figura principal mira al espectador y le ofrece triunfante su sexo, centro geométrico de la obra, mientras deja caer rosas.

The dome is painted using a false architectural perspective, to help unify the eight sections with the central element. Each section depicts a scene representing a classical erotic theme: exhibition, playfulness, contemplation, kissing, etc. All united by a circle, which is the geometrical center of the composition, in which the main figure is seductively looking at the spectator. She is triumphantly offering her sex, while allowing roses to fall down to her feet.

La coupole était peinte avec une architecture de perspective trompeuse et impossible qui unifie ses huit segments avec le dessin central. Chaque session représente une scène illustrant un thème classique de l'érotisme: l'exhibition, le jeu, la contemplation, le baiser, etc. et s'unissent dans un cercle où le personnage principal regarde le spectateur et lui offre son sexe de façon triomphante. Un sexe qui est le centre géométrique de l'œuvre et qui répand des roses.

Die Kuppel ist in einer unmöglichen Perspektive gestaltet, die den Betrachter täuscht und deren acht Segmente in einem zentralen Bild vereint werden. In jedem Abschnitt wird eine Szene dargestellt, die eine klassische Thematik der Erotik aufgreift: die Exhibition, das Spiel, die Beobachtung, der Kuss etc. Die Szenen vereinen sich in einem Kreis, in dem die Hauptfigur den Betrachter anblickt und ihm triumphierend ihre Scham zeigt, das geometrische Zentrum des Werks, und dabei Rosen herabfällen lässt.

La cupola è stata dipinta con un'architettura dalla prospettiva illusoria e impossibile che unifica i suoi otto segmenti con il disegno centrale. Ogni sezione plasma una scena che rappresenta una tematica classica dell'erotismo: l'esibizione, il gioco, la contemplazione, il bacio ecc...Si uniscono in un cerchio in cui la figura principale guarda lo spettatore e gli offre trionfante il suo sesso, centro geometrico dell'opera, mentre lascia cadere delle rose.

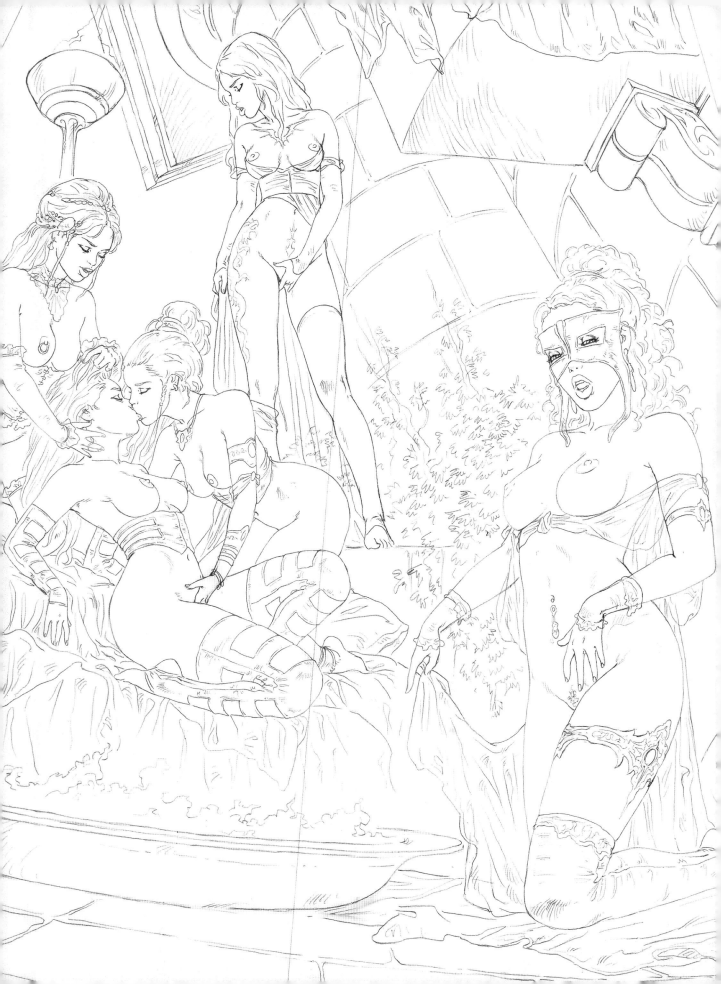

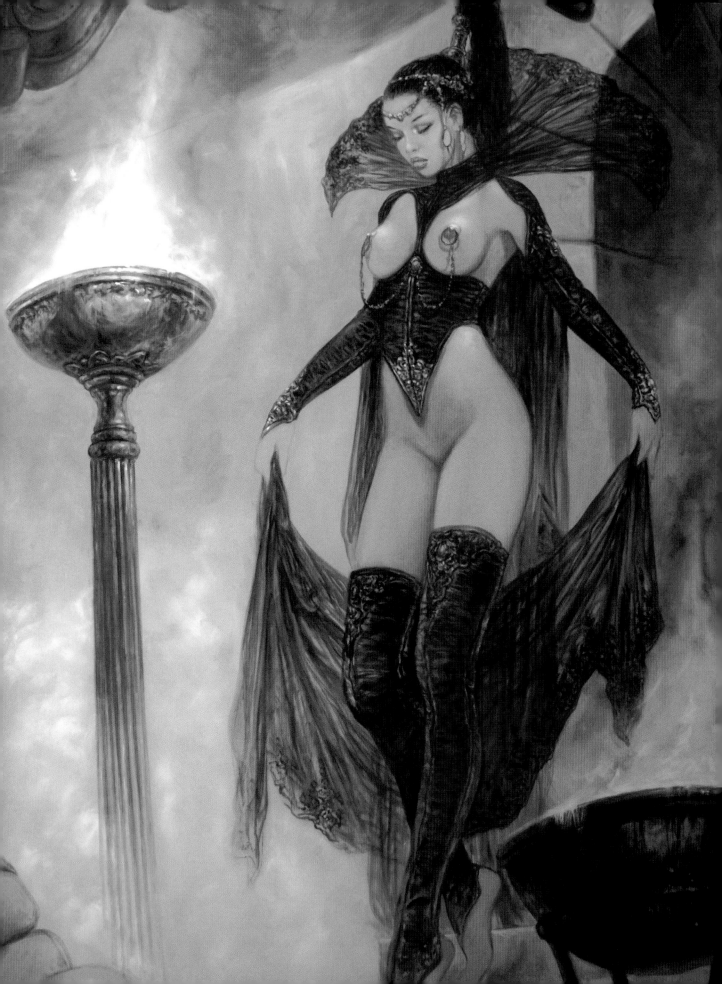

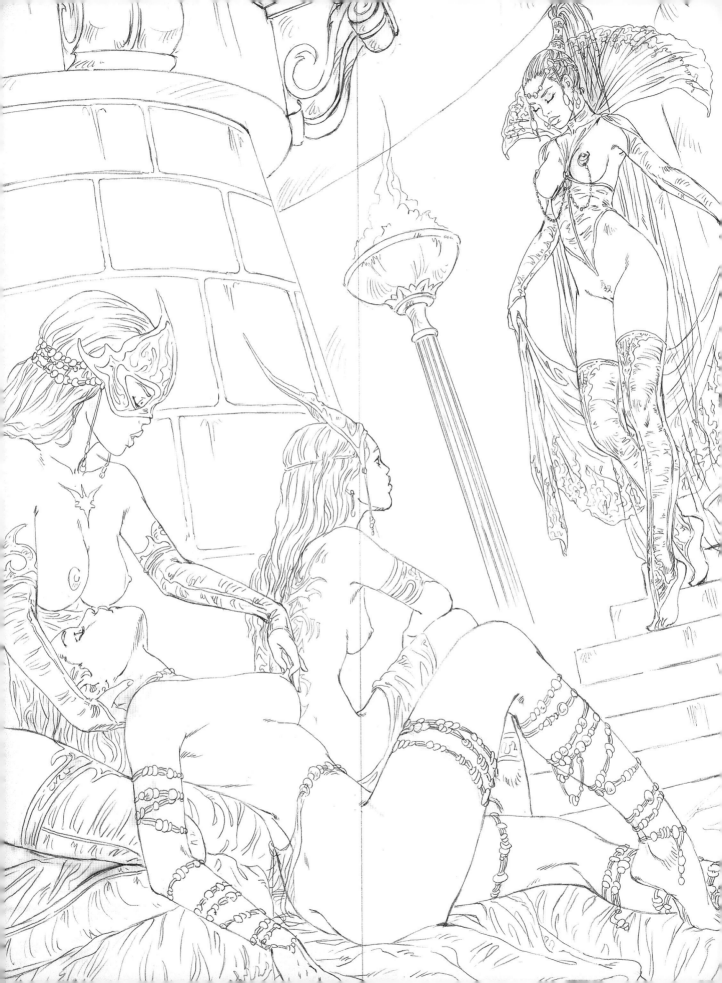

El conjunto es un canto a la belleza ideal y el erotismo femenino, donde los cánones de la realidad no tienen lugar y el hombre sólo puede asomarse con sus defectos entre los matorrales. Una pintura que difícilmente un mecenas dejaría plasmar con tanto descaro en una cúpula de gran tamaño.

The composition is a hymn to idealized female beauty and eroticism, where the canons of reality are not welcome and man, with his manifold defects, can only be seen hiding behind the bushes. The kind of painting you would not expect to see in such a large dome.

L'ensemble est un chant à la beauté idéale et à l'érotisme féminin, où les canons de la réalité n'ont pas de lieu et où l'homme ne peut qu'apparaître de derrière les fagots avec ses défauts. Une peinture d'ailleurs si audacieuse pour une coupole de grandes dimensions, qu'un autre mécène ne l'aurait acceptée que difficilement.

Das Werk ist ein Lobgesang auf die ideale Schönheit und die weibliche Erotik, in dem die Maßstäbe der Realität keinen Platz haben und der Mann mit seinen Mängeln sich nur am Rande zeigen kann. Ein Gemälde, das ein Mäzen nur schwerlich mit soviel Dreistigkeit auf einer großen Kuppel anbringen lassen konnte.

La composizione è un canto alla bellezza ideale e all'erotismo femminile, in cui i canoni della realtà non hanno posto e l'uomo si può solo affacciare tra i cespugli con tutti i suoi difetti. Un dipinto che difficilmente un mecenate farebbe plasmare in modo così sfacciato in una cupola di tale grandezza.

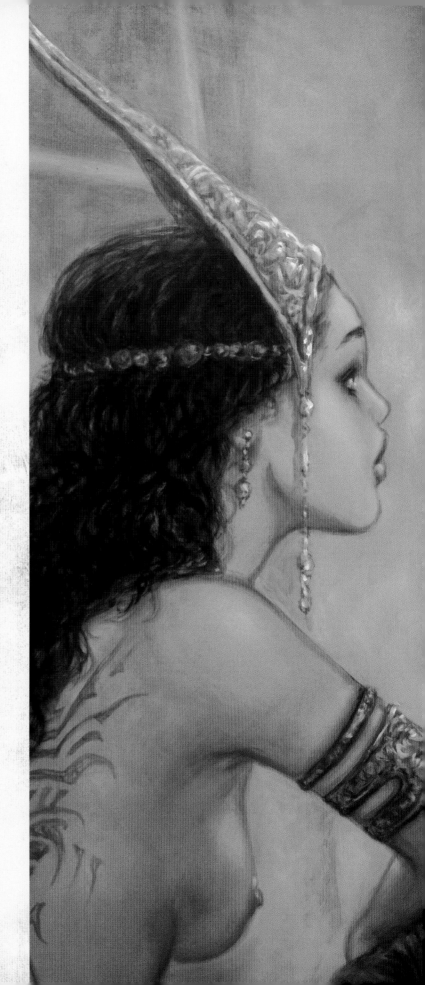

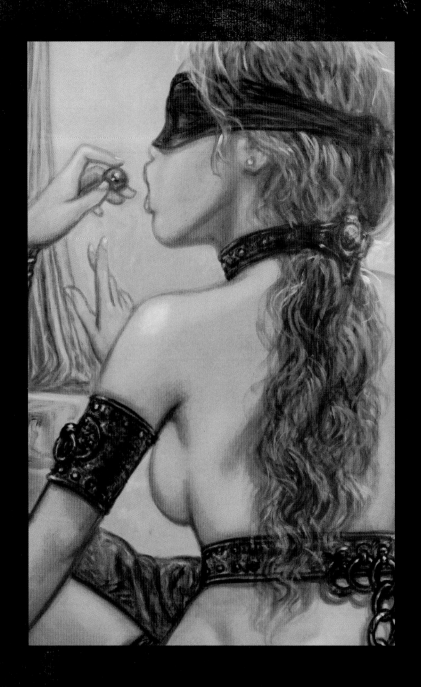

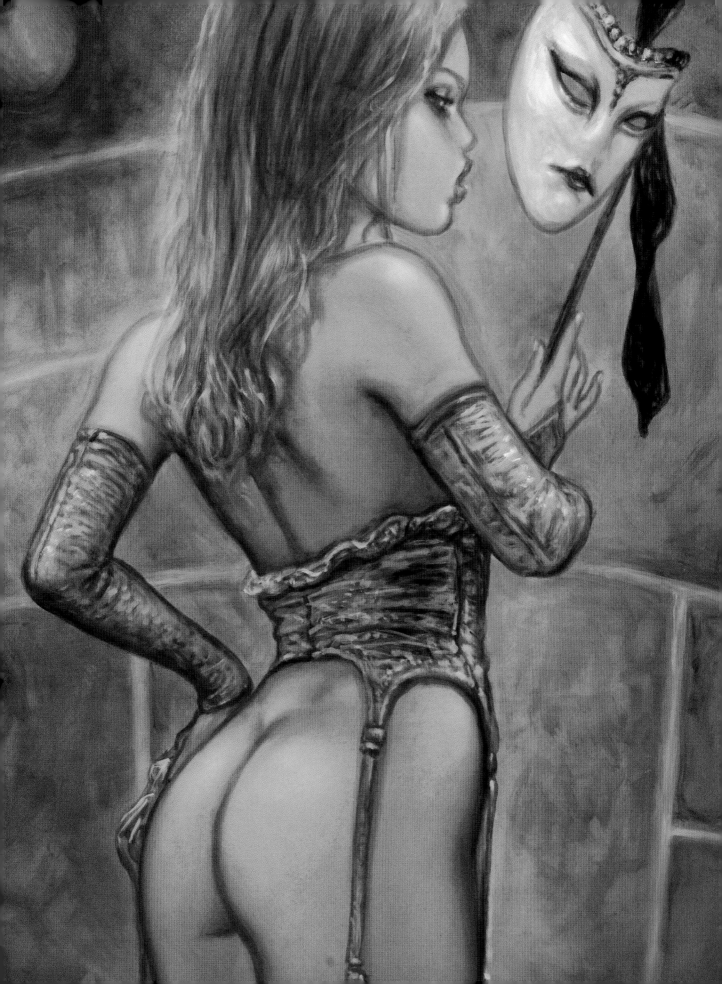

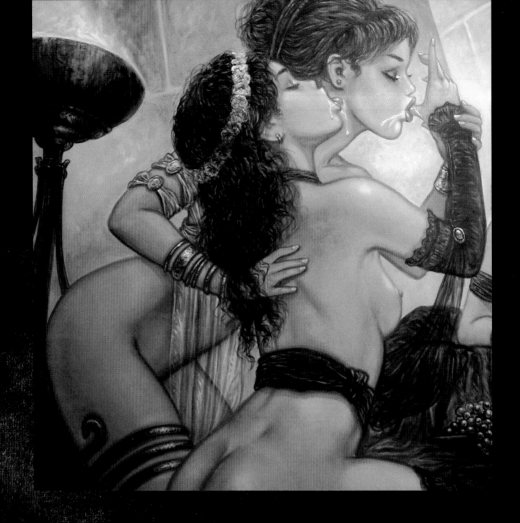

Los últimos días, el agotamiento físico se apoderó de nosotros. La incómoda posición de pintar hacia arriba, el melancólico gris de Moscú y la falta de descanso hicieron mella. A esto se sumó la tensión de ver la obra siempre de cerca, sin perspectiva general, y con la incertidumbre de no tener nunca la visión global que se contemplaría una vez acabada.

During the final days, fatigue was taking its toll on us. The discomfort of painting on our backs, the melancholy of the Moscow skies and the lack of rest were beginning to catch up. We were also physically very close to the work and in relatively tight quarters. Frustratingly, our scaffolding made it impossible to get a sense of the dome as a whole.

Les derniers jours, l'épuisement physique s'empara de nous. Le fait de peindre la tête en haut, ce gris mélancolique de la ville de Moscou et le manque de repos nous

ébranlèrent le moral. S'ajoutait à cet état, le manque de perspective générale au moment de regarder notre œuvre que nous voyions toujours de trop près et donc sans pouvoir la voir finie.

Während der letzten Tage überkam uns die körperliche Erschöpfung. Die unbequeme Haltung, die wir zum malen über unseren Köpfen einnehmen mussten, das melancholische Grau Moskaus und die mangelnde Erholung machten sich bemerkbar. Dazu kam die Anspannung, das Werk immer von Nahem sehen zu müssen, ohne es mit

Abstand betrachten zu können, und das Gefühl, es niemals als fertiges Ganzes sehen zu können.

Negli ultimi giorni, lo sfinimento fisico si impossessò di noi. La scomoda posizione di dipingere guardando in alto, il grigio malinconico di Mosca e la mancanza di riposo ci avevano stremato. A tutto ciò, si aggiungeva la tensione di vedere l'opera sempre da vicino, senza una prospettiva generale, e con l'incertezza di non avere mai la visione globale che si può contemplare, poi, una volta finito il lavoro.

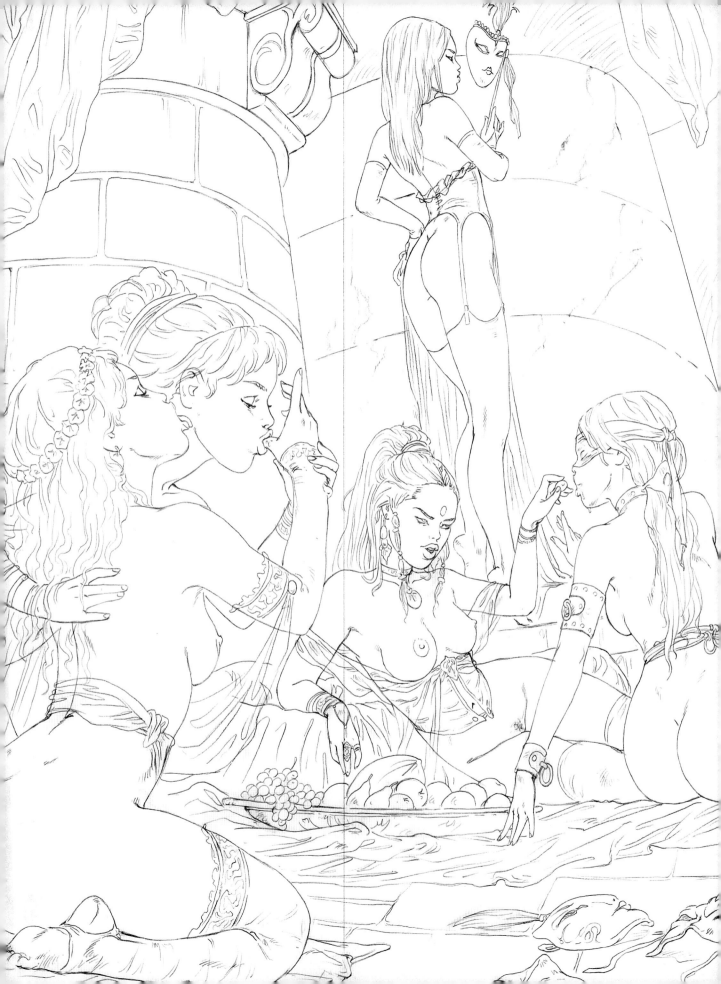

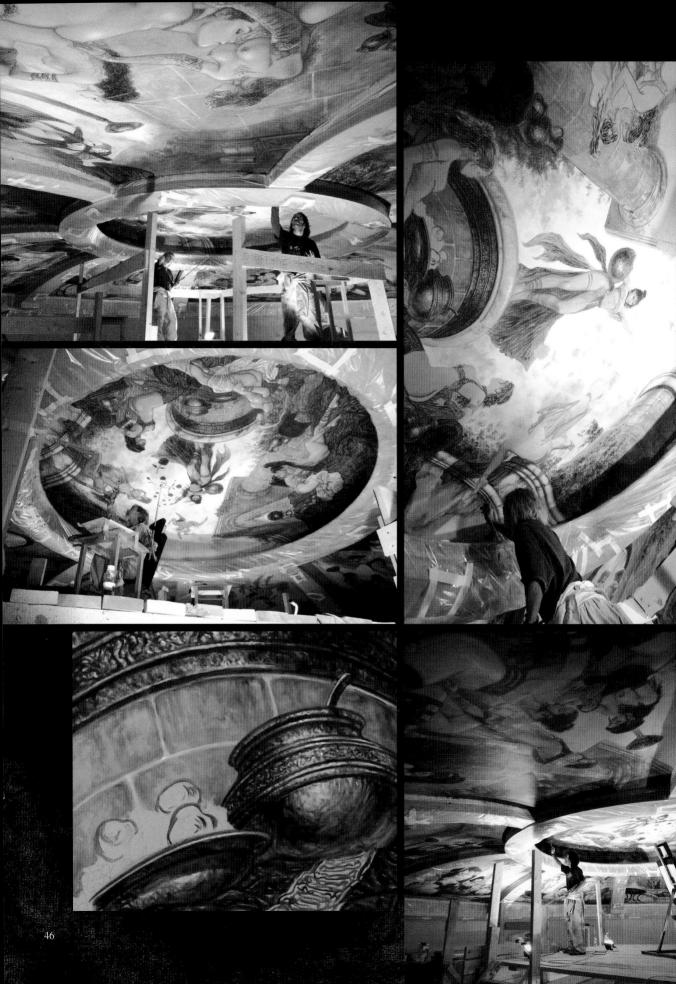

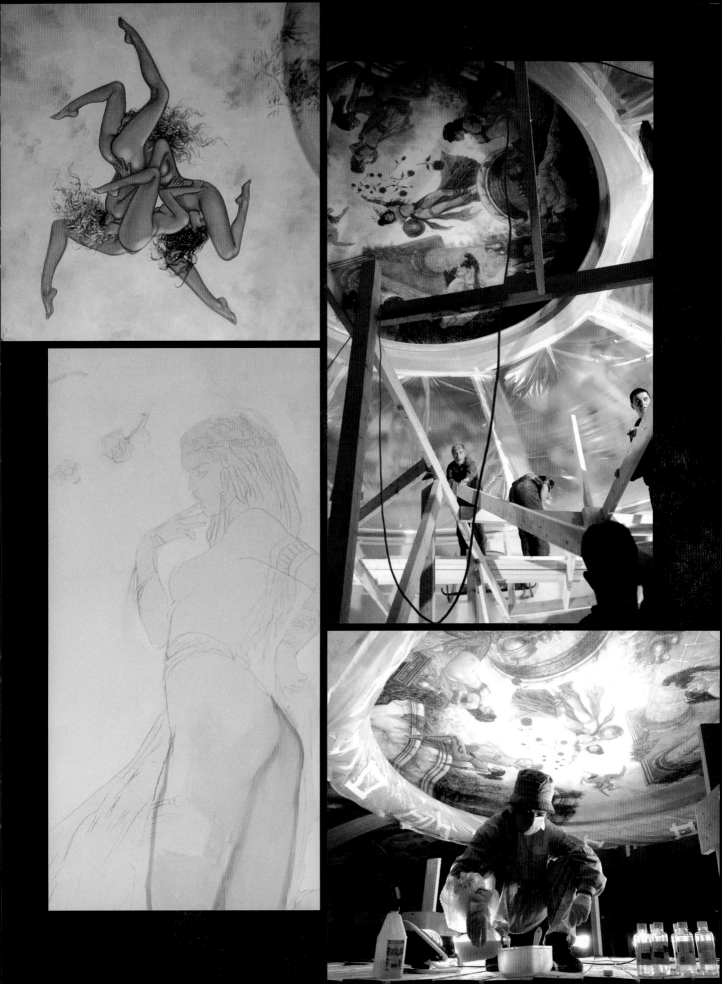

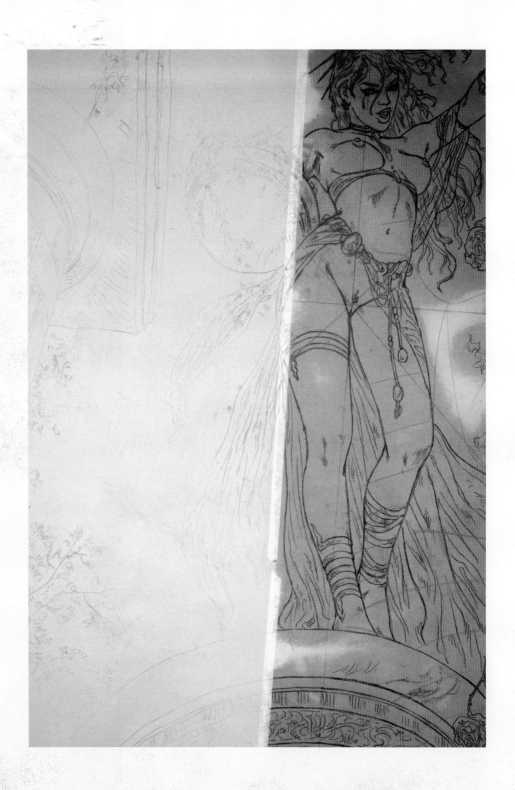

En las figuras, el punto de vista desciende conforme se van aproximando al centro, y su tamaño varía desde los dos metros y medio de las más cercanas al espectador, al metro y medio de las del centro de la cúpula.

When looking at the figures, the point of view descends towards the center, with their size varying from the two and a half meters of the ones closest to the spectator to the meter and a half size of the ones in the center of the dome.

En ce qui concerne les personnages, leur taille varie selon s'ils sont situés près du centre de la coupole ou pas. Les silhouettes de ceux qui sont plus près du spectateur font jusqu'à deux mètres et demi, et celles du centre font un mètre et demi.

Bei den Figuren verringert sich der Betrachtungswinkel je näher sie sich am Zentrum befinden und ihre Größe variiert von zweieinhalb Metern für die Figuren, die dem Betrachter am nächsten sind, bis eineinhalb Metern für die Figuren, die sich im Zentrum der Kuppel befinden.

Nelle figure, il punto di vista si abbassa man mano che si vanno avvicinando al centro e le loro dimensioni variano dai due metri e mezzo di quelle più vicine allo spettatore, al metro e mezzo di quelle che stanno al centro della cupola.

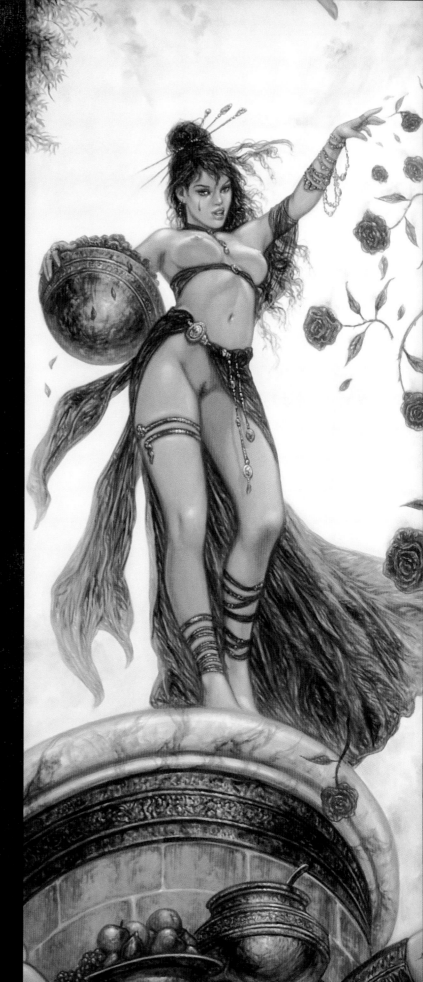

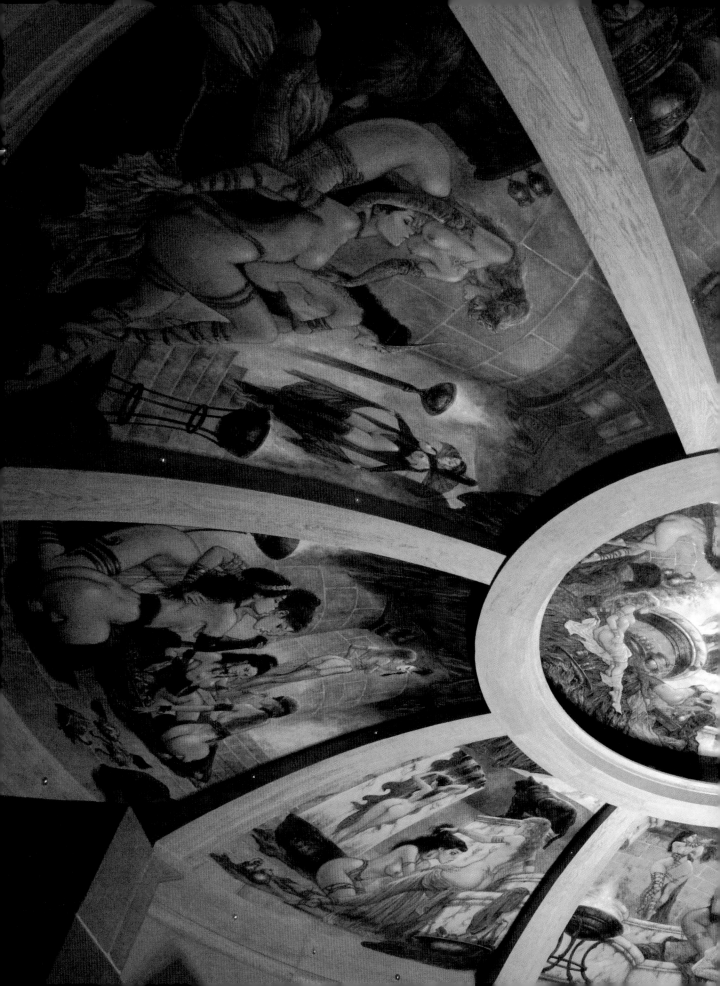

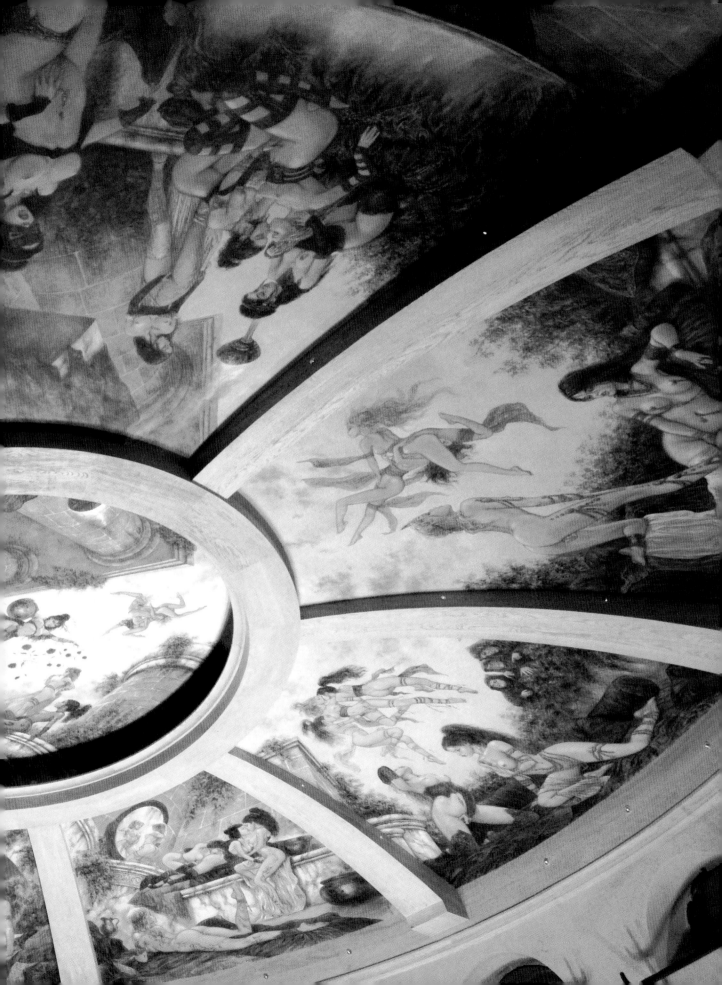

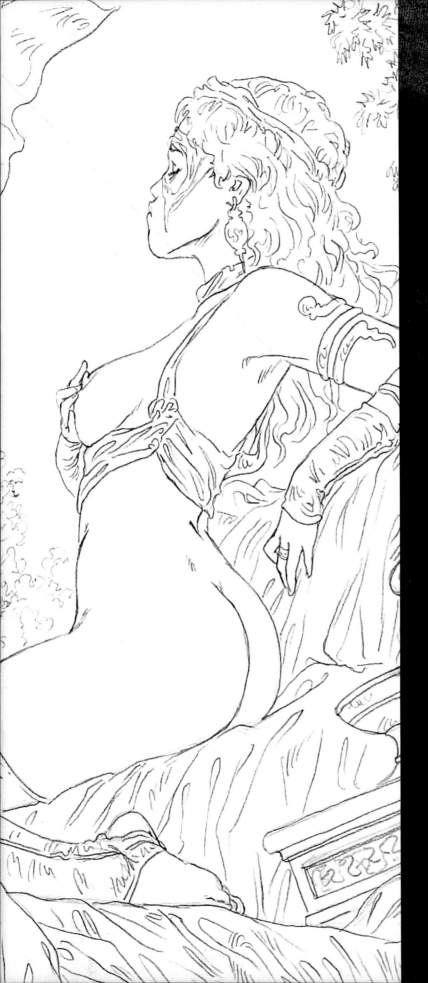

La arquitectura también es engañosa, forzando su perspectiva a medida que se acerca al centro, con un efecto de fuga desde el suelo que resultaría imposible de percibir mientras se pintaba.

There is also a visual trick in the architecture, with the perspective straining as you reach the center, with a fugue effect from the ground that is impossible to perceive while actually doing the painting.

L'architecture est également trompeuse, forçant la perspective au fur et à mesure que l'on s'approche du centre, avec un effet de fugue depuis le sol, imperceptible au moment de peindre.

Auch die Architektur täuscht, die Perspektive ändert sich, je näher man dem Zentrum kommt, mit einer Fluchtperspektive vom Boden aus, die man während des Malens unmöglich wahrnehmen konnte.

Anche l'architettura è illusoria: forza la sua prospettiva man man che si avvicina al centro, con un effetto di fuga dal suolo che era impossibile da percepire mentre dipingevamo.

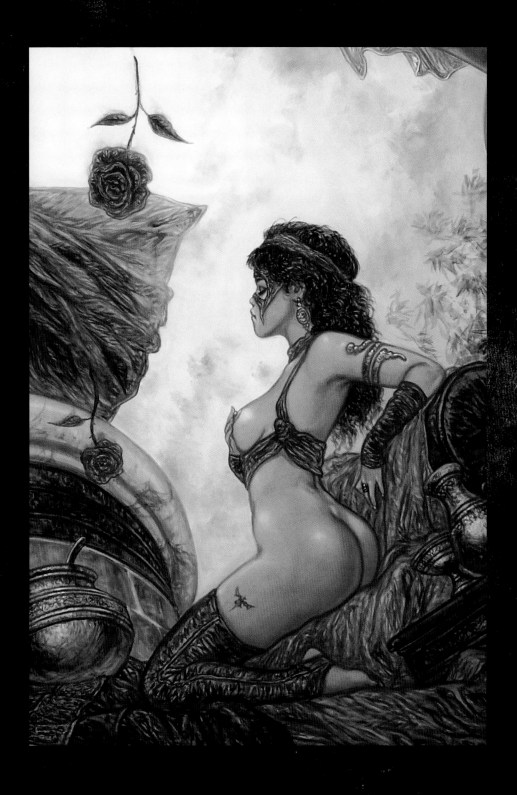

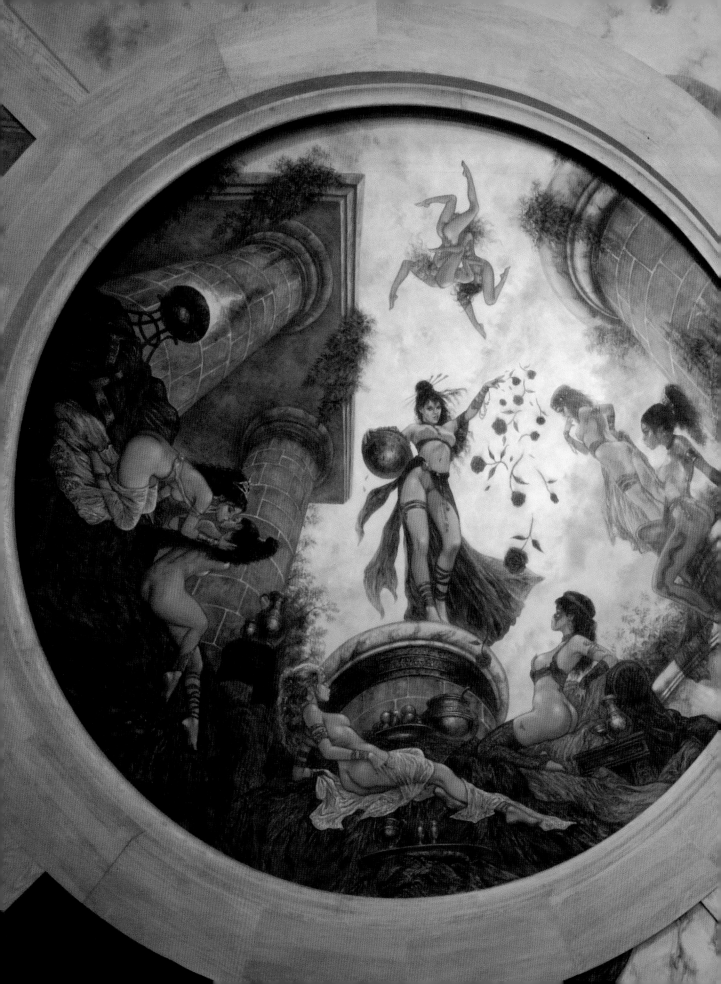

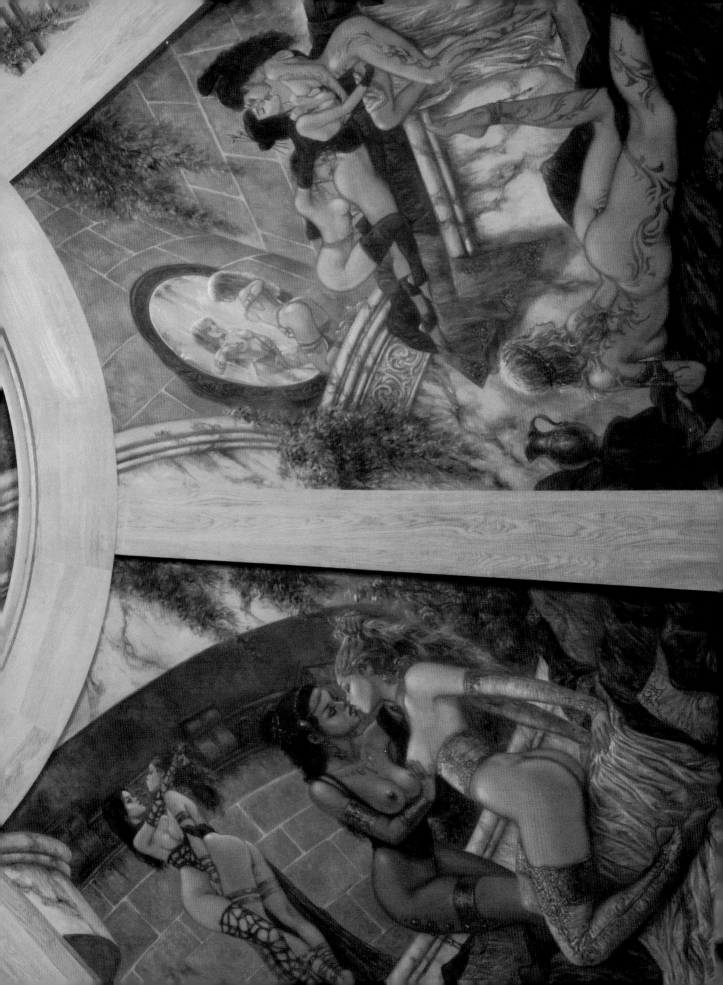

Cuando los andamios se retiraron y la escena nos envolvió por primera vez, nos dimos cuenta de que todo el esfuerzo, las dificultades y la fatiga habían valido la pena.

When the scaffolding was finally removed and the scene enveloped us for the very first time, we were fully conscious that all the efforts, difficulties and fatigue had been worth it.

Quand les échafaudages furent démontés et la scène put enfin nous envelopper pour la première fois, nous nous rendîmes compte que tout cet effort, toutes les difficultés rencontrées et toute notre fatigue valurent le coup.

Als die Gerüste entfernt wurden und die Szene uns zum ersten Mal einhüllte, bemerkten wir, dass sich all die Anstrengung, die Schwierigkeiten und die Ermüdung gelohnt hatten.

Quando l'impalcatura venne tolta e la scena ci avvolse per la prima volta, capimmo che tutto lo sforzo, le difficoltà e la fatica erano valsi la pena.

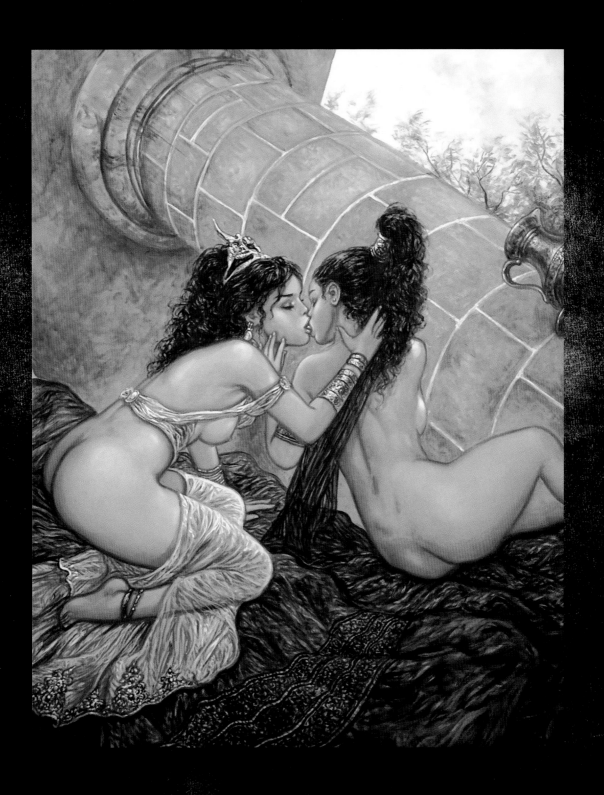

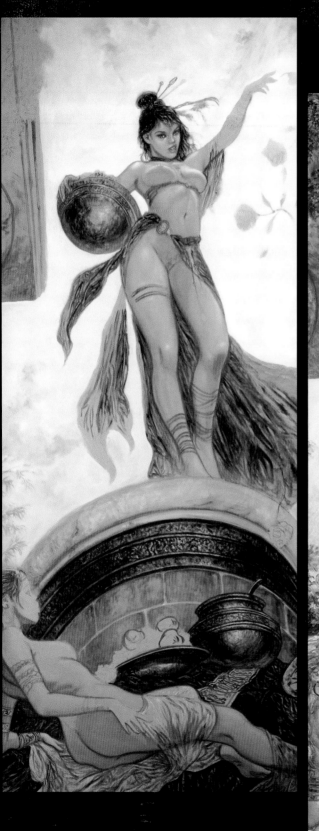
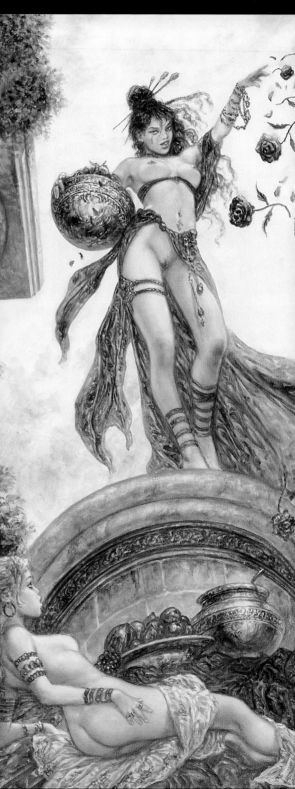

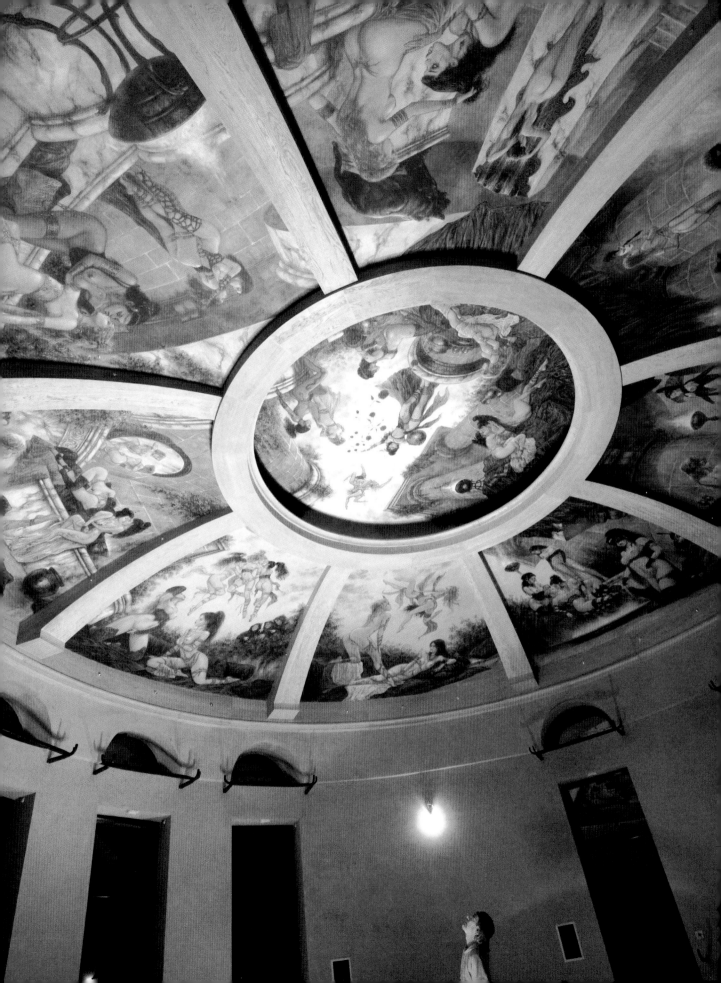

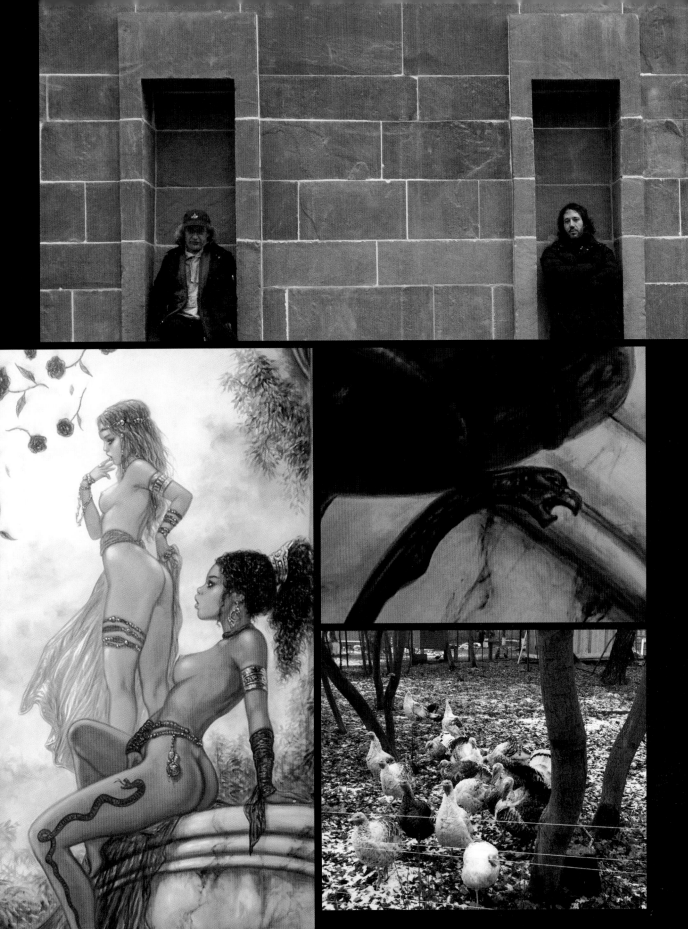

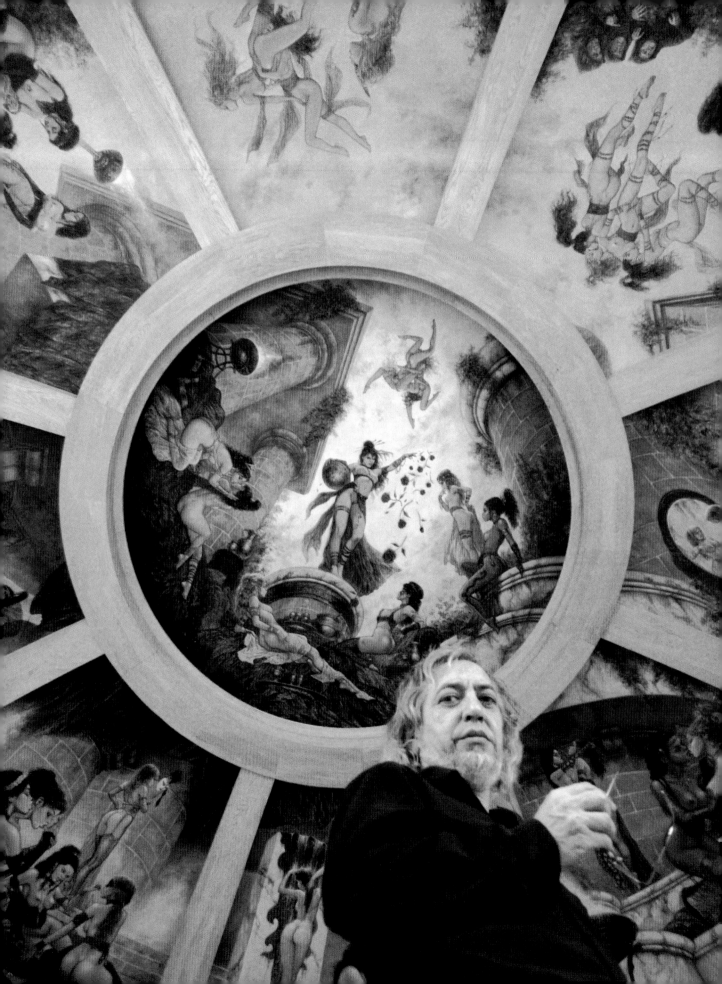

BIBLIOGRAFÍA

BIBLIOGRAPHY – BIBLIOGRAPHIE – BIBLIOGRAFIE – BIBLIOGRAFIA

Libros de ilustración
Illustrated books – Livres illustrés
Bildbände – Libri d'illustracione

WOMEN – MALEFIC – SECRETS
III MILLENNIUM – DREAMS – EVOLUTION
PROHIBITED BOOK I – PROHIBITED BOOK II
PROHIBITED BOOK III – PROHIBITED SKETCHBOOK
CONCEPTIONS I – CONCEPTIONS II – CONCEPTIONS III – VISIONS
FANTASTIC ART – THE LABYRINTH: TAROT
SUBVERSIVE BEAUTY – WILD SKETCHES I – WILD SKETCHES II

Colecciones de Trading Cards – Trading Cards Collections – Collections de Trading Cards
Trading-Cards-Kollektionen – collezione de carte

FROM FANTASY TO REALITY – FORBIDDEN UNIVERSE
THE BEST OF ROYO – SECRETS – MILLENNIUM – PROHIBITED

Portafolios – Portfolios – Portfolios – Portfolios – Portafoglio

WARM WINDS – III MILLENNIUM – TATTOOS – CHAINS
PROHIBITED: SEX – TATTOO-PIERCING. SUBVERSIVE BEAUTY

Otros – Others – Autres – Andere – Altri

THE BLACK TAROT – STRIPTEASE POSTCARDS – POSTERS
WOMEN BY ROYO – PLAYING CARDS
THE LABYRINTH: TAROT'S PACK OF CARDS

Cómic – Fumetto – BD – Comics – Fumetti

ANTOLOGÍA 1979-1982.
VOL.1 de 4

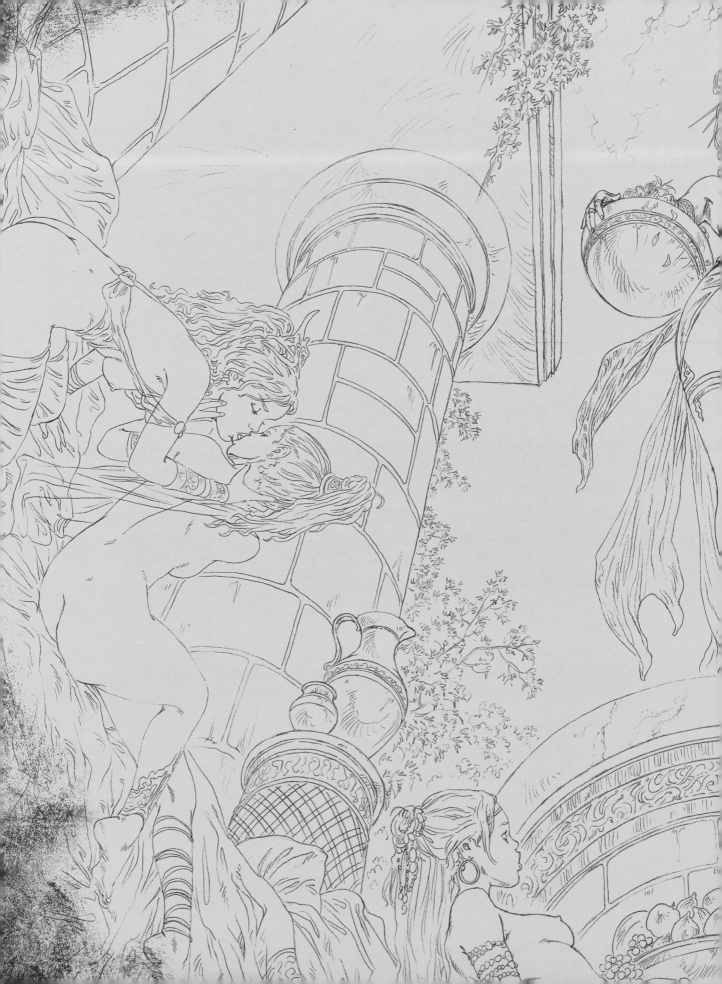